Along the Delaware River

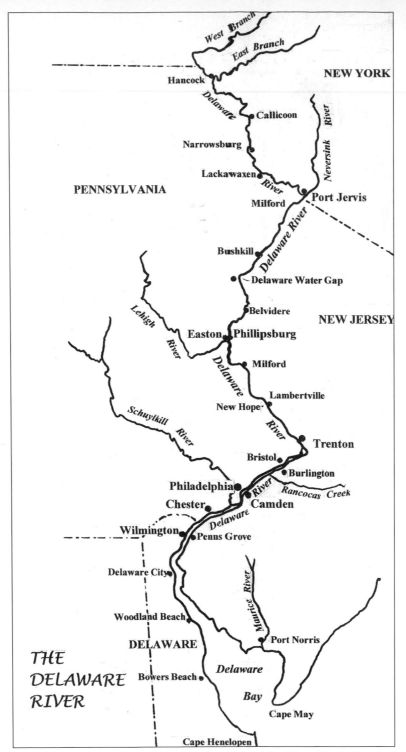

The 330-mile Delaware River is a major U.S. river shared by New York, Pennsylvania, New Jersey, and Delaware. The river corridor is uniquely historic, scenic, and diverse.

POSTCARD HISTORY SERIES

Along the Delaware River

Richard C. Albert and Carrie E. Albert

ARCADIA

First printed in 2002.

Published by Arcadia Publishing,
an imprint of Tempus Publishing, Inc.
2A Cumberland Street
Charleston, SC 29401

Printed in Great Britain.

Library of Congress Catalog Card Number: 2002100065

For all general information contact Arcadia Publishing at:
Telephone 843-853-2070
Fax 843-853-0044
E-Mail sales@arcadiapublishing.com

For customer service and orders:
Toll-Free 1-888-313-2665

Visit us on the internet at http://www.arcadiapublishing.com

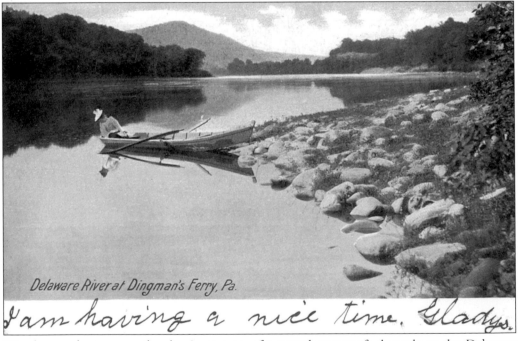

Delaware River at Dingman's Ferry, Pa.

I am having a nice time. Gladys.

Wooden rowboats were the dominant type of personal watercraft throughout the Delaware River region c. 1900, followed by sailboats and canoes. This postcard shows a beautiful example of one beached at Dingmans Ferry, Pennsylvania. The sender of this card wrote, in August 1907, "I am having a nice time"—a sentiment echoed up and down the river.

CONTENTS

ACKNOWLEDGMENTS

The postcards in this book come from the collection of Richard C. Albert. Numerous sources of information were examined in writing the text. Sources included many publications and Internet sites created by a variety of organizations, agencies, and private individuals. If we could name each individual who contributed to the information, the list would certainly include Manville B. Wakefield, Warren F. Lee, Frank Dale, William F. Henn, George J. Fluhr, David Budlong Tyler, Francis R. Holland Jr., Joshua Pine III, Gary Letcher, David Veasey, Priscilla M. Thompson, Sally O'Byrne, and countless others. We thank Judith Strong, Delaware River Basin Commission librarian, who made the commission's library collection available to us, and Mary Albert for her support and encouragement.

To Jane Harlan and the late Boyd Harlan.

INTRODUCTION

In the spring of 1764, Dan Skinner pushed a lumber raft off the banks of the upper Delaware River and headed to Philadelphia, Pennsylvania. For the next 150 years, men like Skinner made lumber rafting big business on the river. Each year, hundreds of rafts headed downriver. Like all the chapters in the Delaware River story, lumber rafting reflects the interactions of people and their natural landscape along a river corridor.

The Delaware River begins as two tiny trickles of water flowing from springs high in the Catskill Mountains of New York. The northern trickle becomes the West Branch of the Delaware River, and the southern one, the East Branch. In the town of Hancock, New York, the two tributaries merge, forming the Delaware River. From there, the river flows 331 miles to the Atlantic Ocean. At Trenton, New Jersey, 200 miles from Hancock and 134 miles from the Atlantic Ocean, the river becomes tidal. The last 48 miles of the tidal reach is Delaware Bay. Almost 60 rivers in the United States are longer than the Delaware River, and 32 of these carry more water in a typical year.

People have been working and playing along the Delaware River for thousands of years. It was the home of the Lenni Lenape (or Delaware Indians) prior to the arrival of European settlers. In 1610, Henry Hudson and the Dutch ship *Half Moon* wandered into Delaware Bay. Hudson named the river the South River. In the following year, Samuel Argall discovered it for England. Argall named what is now Cape Henlopen after Virginia's governor, Lord De La Warre. After the English gained control of the region from the Dutch in 1664, the name De La Warre was applied to the whole river.

The Delaware River region is the birthplace of the American Revolution. On July 4, 1776, the Declaration of Independence was signed in Independence Hall, several blocks from the river in Philadelphia. Six months later, General Washington and his ragtag army made their daring nighttime crossing of the Delaware and saved the Revolution. In 1787, the Constitutional Convention met in Philadelphia and drafted the U.S. Constitution.

It can be argued that the industrial revolution began in the United States with the first shipment of coal to Philadelphia, via the Lehigh Canal and the Delaware River. Beginning in the mid-18th century, industrial development along the tidal Delaware made the region one of the largest urban-industrial complexes in the world. It remains the second largest concentration of petro-chemical plants in the United States. Seventy percent of oil delivered to the east coast goes to Delaware River refineries.

A boundary is created by the Delaware River between four states: Delaware, New Jersey, New York, and Pennsylvania. Eight million people live in its 13,539-square-mile watershed. Although

the watershed is only two fifths percent of the land area in the United States, almost eight percent of the population gets water from it, including New York City and Philadelphia.

The Delaware is one of the last undammed major rivers in the United States. It is not, however, completely free flowing. During times of low flow, reservoirs owned by New York City and various power companies release much of the water seen farther south in the river. These flows are mandated by a 1931 U.S. Supreme Court decree, amended in 1954, that allowed large water-supply reservoirs to build on the West Branch, East Branch, and Neversink Rivers in New York. In spite of the reservoir releases, it is still very much a natural river.

Recreation is also an important part of the history of the Delaware River. Certainly one of the first resort hotels in the United States, the Kittatinny House was opened in 1833 in the Delaware Water Gap. The Delaware has been a source of good times for over two centuries, and millions still enjoy the river each year, making it one of the premier recreational rivers in the country. More than 175 miles of the 200-mile nontidal Delaware have been placed in the National Wild and Scenic Rivers System; the crown jewels of American rivers.

Heading downriver—whether by raft, canoe, or boat—is a Delaware River tradition. Although nothing can replace the real experience, this book offers a vicarious journey down the river as it appeared in the early 20th century.

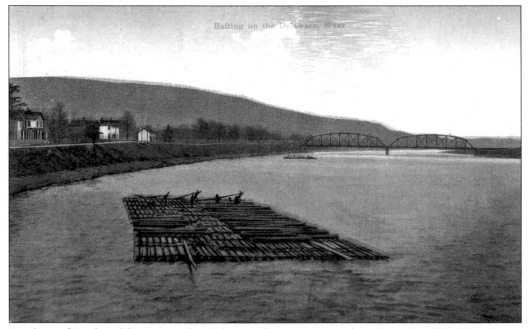

Lumber rafting lasted longer on the Delaware than on many other rivers. In 1783, New Jersey and Pennsylvania restricted dams on the Delaware to avoid impeding rafts traveling downriver. The existence of this treaty, many years later, helped keep the Delaware River mainstream free of dams. In this view, two rafts are heading downstream. The location is unidentified.

One
HEADWATERS TO PORT JERVIS, NEW YORK

The first section of our trip is the upper Delaware River that flows between Pennsylvania and New York. The West Branch and East Branch of the river flow west from the Catskill Mountains and join in Hancock, New York, to form the Delaware River. The upper Delaware travels 77 miles to Port Jervis, New York. It is the steepest section of the river, with an average drop of more than six feet per mile. The river actually steps down the valley in a series of pools and riffles, creating many whitewater rapids. The deepest spot in the entire river system is found at Big Eddy in Narrowsburg, New York.

At the end of the 19th century, the upper Delaware had a variety of industries that have disappeared, or have nearly disappeared, in the intervening years. In some cases, the towns associated with them have perished too. The Delaware and Hudson Canal, once a major force in the upper river, was abandoned in 1898. Most travel into and out of the region was done via the Erie Railroad.

Tourism is the leading industry along the upper Delaware. A world-class trout fishery exists in the river. Most people, however, come for the scenery, canoeing, and rafting. In 1978, Congress designated all but the last five miles of the reach as the Upper Delaware Scenic and Recreational River, a component of the National Wild and Scenic Rivers System and a unit of the National Park System.

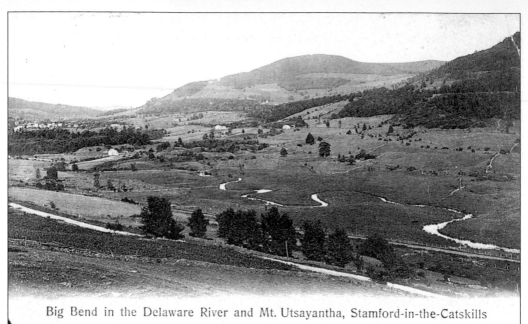

Big Bend in the Delaware River and Mt. Utsayantha, Stamford-in-the-Catskills

No. 10088 Barton & Spooner, Cornwall o/H , N.Y. (Germany)

The West Branch of the Delaware River flows from a spring on a farm outside of Stamford, New York, to Hancock, New York, about 75 miles to the southwest. In this view, the future river is still a meandering creek, flowing through wetlands and farm fields.

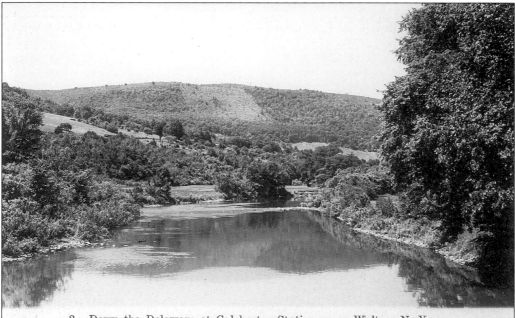

8—Down the Delaware at Colchester Station, near Walton, N. Y.

Walton, New York, lies upstream of today's Cannonsville Reservoir, a major New York City water-supply facility. Walton was a center of the large upper Delaware milk industry. In its heyday, high-speed milk trains rushed fresh milk from the Catskills to New York and other cities in the early morning.

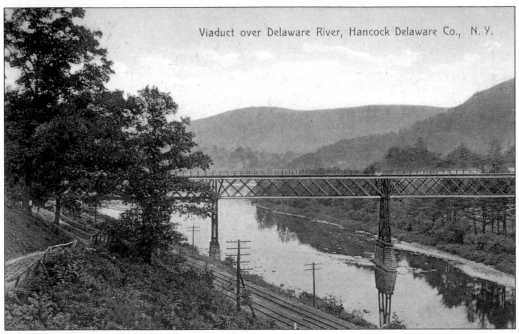

Viaduct over Delaware River, Hancock Delaware Co., N. Y.

The New York, Ontario, and Western Railway reached the Hancock-Cadosia, New York area shortly after the Civil War. In 1890, the railroad opened a line from the coal fields in Scranton, Pennsylvania. The line crossed the West Branch on the bridge shown here before it looped around Hancock to connect with the main line. The Erie Railroad is seen under the bridge. The New York, Ontario, and Western line was abandoned in 1957.

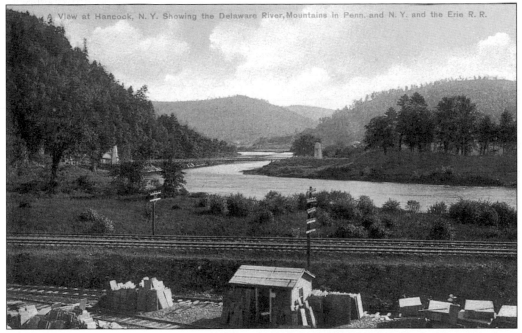

A View at Hancock, N. Y. Showing the Delaware River, Mountains in Penn. and N. Y. and the Erie R. R.

In this view, the Erie Railroad leaves the West Branch and heads into downtown Hancock, New York. The western side of Point Mountain is seen on the left. A suspension bridge that crossed the river is barely visible where Pennsylvania Route 191 crosses today.

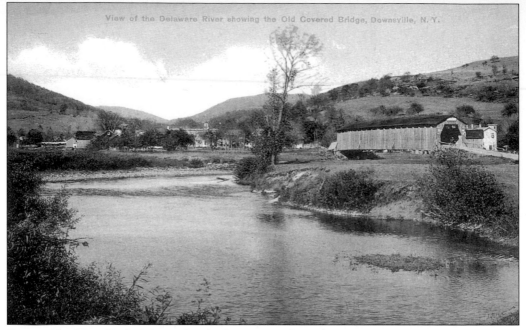

View of the Delaware River showing the Old Covered Bridge, Downsville, N. Y.

Downsville, New York, is immediately downstream from the Pepacton Reservoir, a major New York City reservoir. Its completion in 1955 changed the East Branch from a warm-water fishery to a cold-water one. The covered bridge was built in 1854 and still stands.

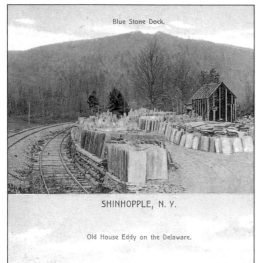

Blue Stone Dock.

SHINHOPPLE, N. Y.

Old House Eddy on the Delaware.

This scene at Shinhopple, New York, about 20 miles upstream from Hancock, New York, on the East Branch, was a common one along the Delaware. The bluestone industry extended as far south as the Delaware Water Gap. Rows of bluestone slabs are awaiting pickup by the Delaware and Northern Railroad, a small line serving the valley from Hancock to Arkville, New York.

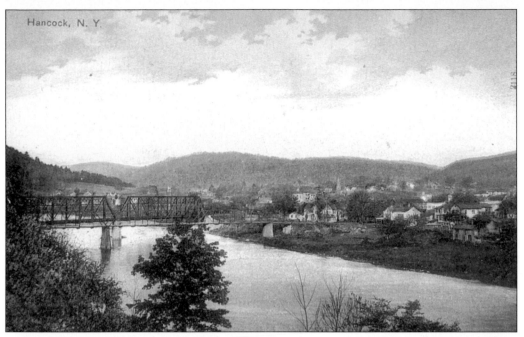

Hancock, N. Y.

Northbound Erie Railroad trains crossed the East Branch of the Delaware River to enter Hancock, New York. The east side of Point Mountain is seen on the left. The highway bridge upstream of the railroad is now New York Route 97. Today, the Norfolk Southern Railroad operates freight trains on the old Erie line.

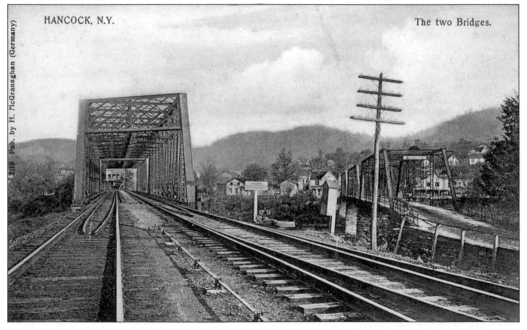

HANCOCK, N.Y.

The two Bridges.

2110 Pub. by H. McGranaghan (Germany)

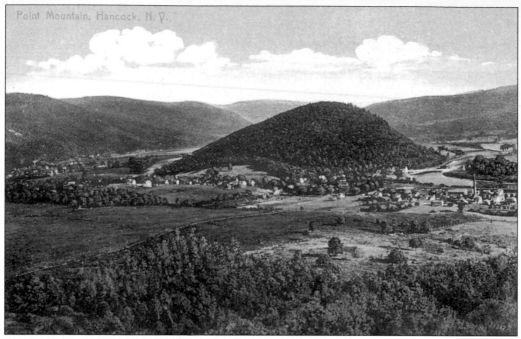

In a view looking south, Point Mountain hides the confluence of the two branches of the Delaware River. The West Branch on the right snakes its way to the junction, while the valley of the East Branch is to the left of the mountain.

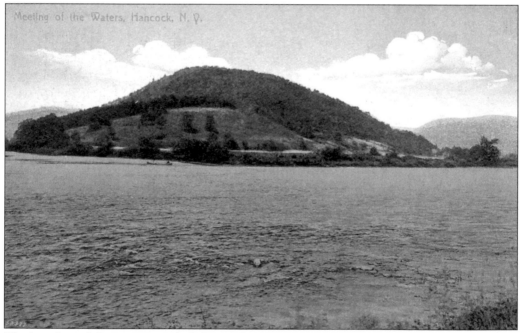

The junction of the West Branch (left) and the East Branch (right) is shown in this view looking north. The Delaware River begins here, and Point Mountain stands timelessly over the scene. Today, the mountain is totally forested. An abandoned mausoleum and a communication tower mar its summit. From here to the Atlantic Ocean, the Delaware River flows 331 miles.

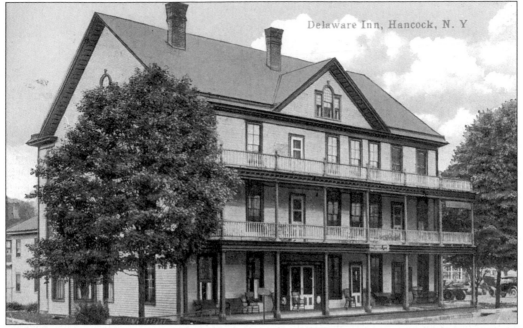

Delaware Inn, Hancock, N. Y

In the past, travelers to many towns along the Delaware could expect to find an establishment called the Delaware Hotel, Delaware Inn, or Delaware House. These establishments—such as this one in Hancock, New York—served the drummers, lumber raftsmen, and others who passed their way.

We are surveying here across the river.

will probably be home Sunday. Hale.

Nineteenth-century canoeists who disembarked from the afternoon Erie passenger train had a short day on the river. A good paddle would find them within sight of Lordville, New York, seen off in the distance in this postcard. The smoke rising from the town indicates a train working its way upriver.

15

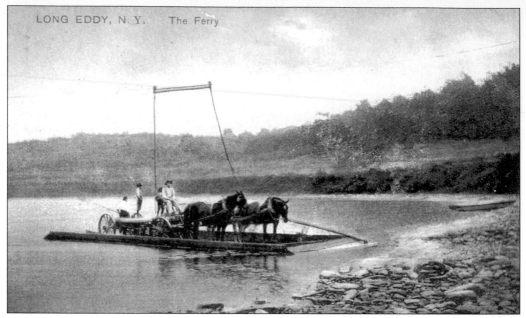

LONG EDDY, N. Y. The Ferry

Today, almost the same number of bridges cross the river above Trenton, New Jersey, as in 1900, but the slower travel times of horses and buggies required river crossings at more locations. Rope ferries made up the difference. The main function of this one may have been to reach agricultural fields in Pennsylvania or to collect wood and bark for the wood-chemical plant that existed in Long Eddy, New York.

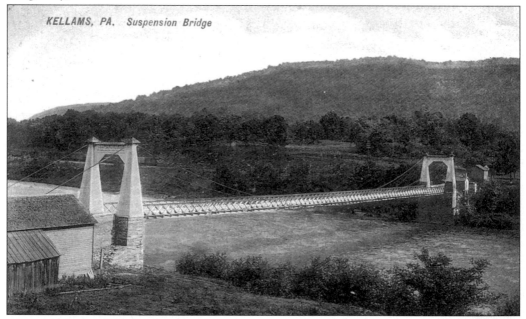

KELLAMS, PA. Suspension Bridge

The Little Equinunk Bridge Company built the one-lane Kellams Bridge in 1883. It is similar to the many other suspension bridges that crossed the Delaware prior to the October 1903 flood. This bridge connected northern Wayne County, Pennsylvania, with the Erie Railroad in New York, seen on the right. It has been extensively repaired in recent years and still carries traffic between the two states.

16

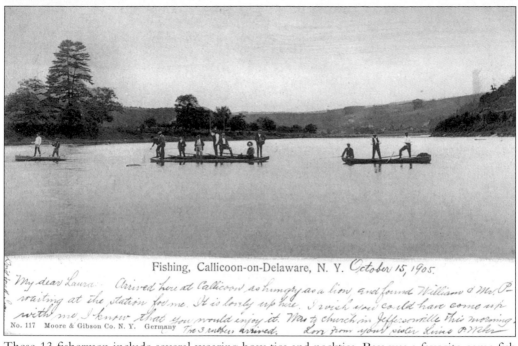

Fishing, Callicoon-on-Delaware, N. Y. *October 15, 1905.*

These 13 fishermen include several wearing bow ties and neckties. Bass was a favorite game fish in the upper Delaware. Now that the upper river is influenced by the cold-water releases from the New York City water-supply reservoirs, trout is king.

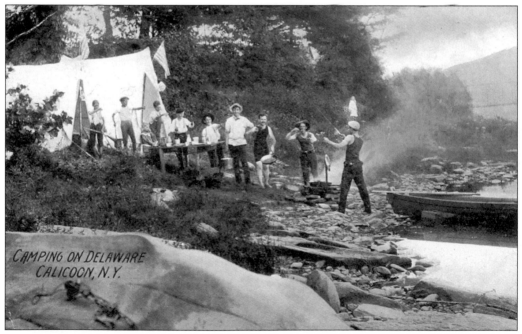

Camping in the late 19th and early 20th centuries was not a "go light" affair. Most of the equipment used was designed for other purposes. This group of happy-go-lucky campers has heavy canvas tents, a table, cast-iron cookware, a rifle, and strong backs to carry it all.

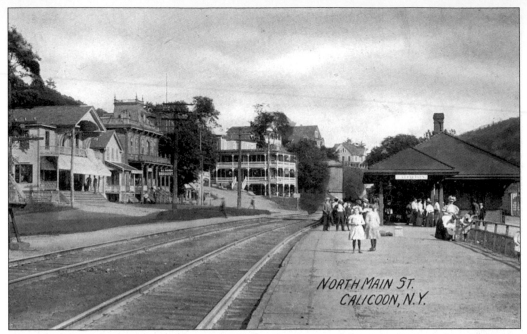

Callicoon, New York, was a jumping-off point for the Catskill Mountains. Today, it remains remarkably unchanged from how it appears in this postcard. The Delaware is down the hill to the right. The Western Hotel, partially hidden behind the big tree, still awaits travelers with rooms and refreshment.

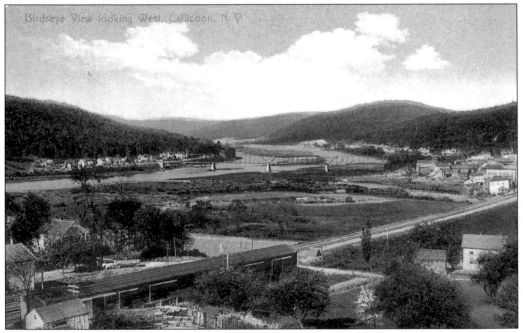

In this aerial view looking up the Delaware River corridor, Callicoon appears on the right. Callicoon Creek can be seen entering the Delaware River shortly after passing under the high Erie Railroad Bridge, just out of view. Wayne County, Pennsylvania, is on the western side of the river.

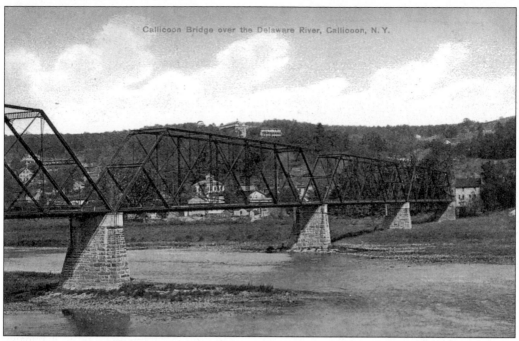

The Callicoon Bridge Company built this span in 1898. It was raised a foot higher during the following year, after being threatened during an ice jam, and was eventually replaced in the 1960s. Callicoon appears in the background.

The small villages of Damascus, Pennsylvania, and Cochecton, New York, are twin communities along the Newburgh-Great Bend Turnpike. A large oil-pumping station, with a 108-foot-tall stack and oil tanks, was located downstream of Cochecton. Built in 1880, this facility was part of the first long-distance oil pipeline in the United States. It ran from Olean, New York, to Bayonne, New Jersey.

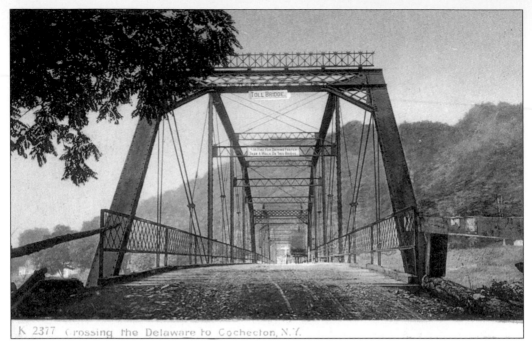

K 2377 Crossing the Delaware to Cochecton, N.Y.

The above view looks through the Cochecton-Damascus bridge into New York. The village of Cochecton is about a quarter mile farther. The signs hanging from the bridge read, "Toll Bridge" and "$10 Fine for Driving Faster than a Walk on This Bridge." It is doubtful that the buggy leisurely crossing the bridge is going to be fined. The view below looks upstream from the bridge into Damascus, Pennsylvania.

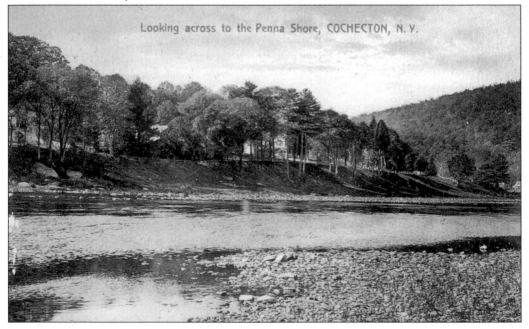

Looking across to the Penna Shore, COCHECTON, N. Y.

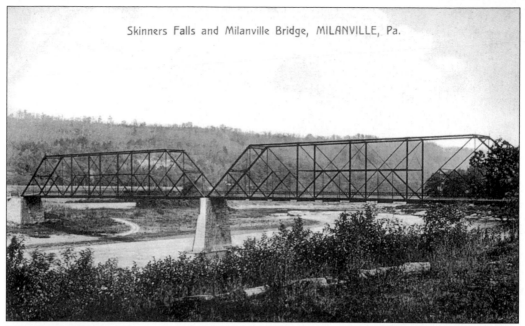

Skinners Falls and Milanville Bridge, MILANVILLE, Pa.

The Milanville Bridge Company built the 470-foot, single-lane Milanville Bridge in 1902. Initially, all the bridges that crossed the Delaware River were privately owned toll bridges. In the 1920s, state agencies began purchasing the bridges and eliminating their tolls. In the intervening years, many have also been replaced.

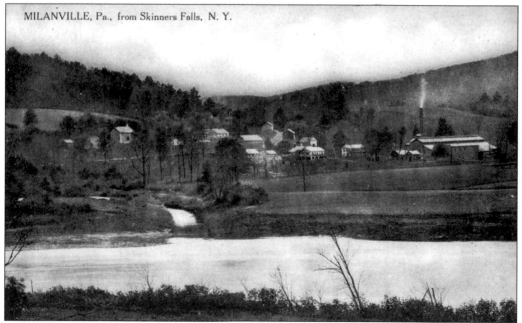

MILANVILLE, Pa., from Skinners Falls, N. Y.

Milanville, Pennsylvania, has not grown much larger than shown in this postcard. Calkins Creek is pictured to the left of the center, entering the Delaware River. The creek undoubtedly dumped pollutants into the Delaware from the pre–World War I Milanville Acid Factory, operated by the Brant-Ross Chemical Company, and the lumbermill (seen here), operated by the Skinner brothers.

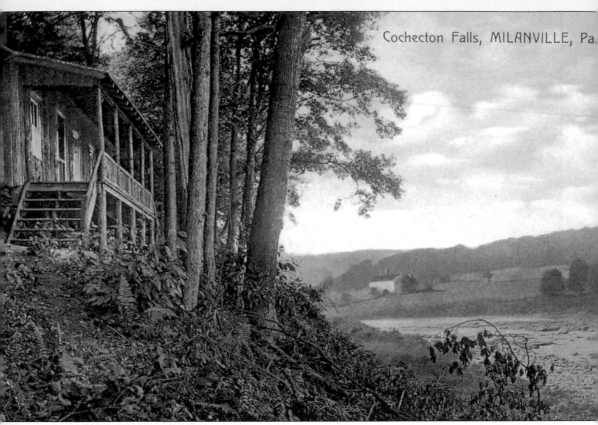

Cochecton Falls, MILANVILLE, Pa.

Cochecton Falls, known today as Skinners Falls, was one of the three rapids that lumber raftsmen, canoeists, and anyone else heading downriver had to worry about. Today, a large canoe-livery campground, a state river-access area, a National Park Service kiosk, and an inner tube–rental outfit help make this the most visited location on the Upper Delaware Scenic and Recreational River.

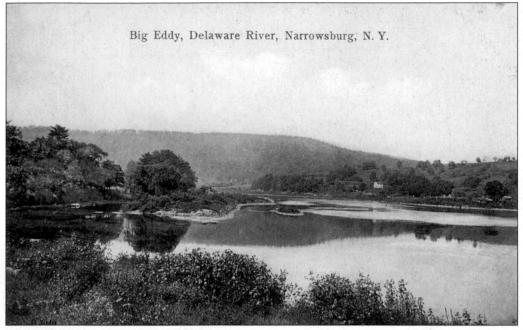

Big Eddy, Delaware River, Narrowsburg, N. Y.

The Big Eddy at Narrowsburg, New York, contains the deepest spot in the entire Delaware River and Bay—about 110 feet, depending on river levels. Eddies like this one, where the river current moves in a circle and flows upstream, were ideal for parking lumber rafts for the night. The Big Eddy, however, could trap rafts for days if the wind blowing upriver was strong enough.

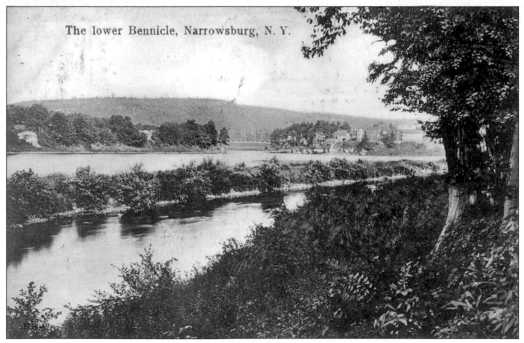

The lower Bennicle, Narrowsburg, N. Y.

This postcard shows the Delaware River downstream of Big Eddy. The view is looking upstream. The village of Narrowsburg, New York, the rocky narrows, and the town's bridge appear in the distance.

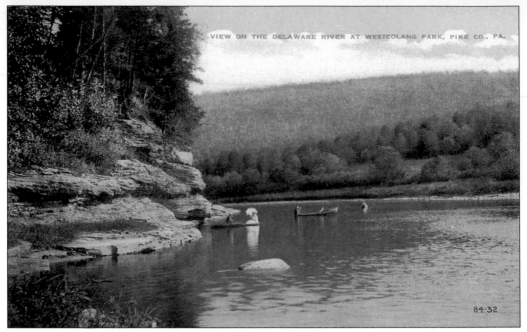

VIEW ON THE DELAWARE RIVER AT WESTCOLANG PARK, PIKE CO., PA.

84-32

These two scenes at Westcolang Park, Pennsylvania, nine miles downstream from Narrowsburg, New York, were obviously taken the same day. Both views look downstream. A free-flowing river, like the Delaware, consists of a series of regularly spaced pools and riffles with a spacing that correlates to channel width. The Westcolang pool is followed by a riffle, as seen in the postcard above. Note the interesting variety of wooden rowboats in the scenes.

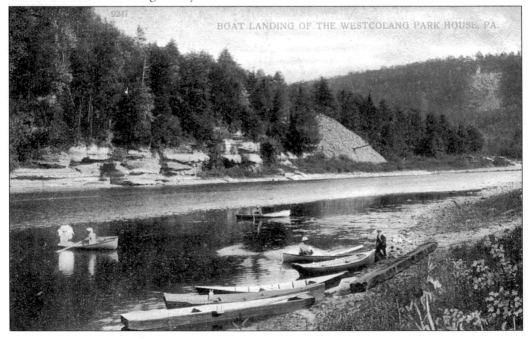

BOAT LANDING OF THE WESTCOLANG PARK HOUSE, PA.

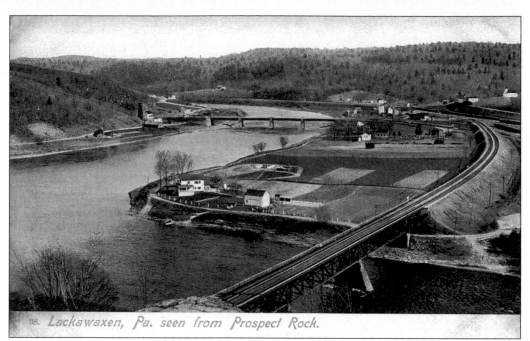

88. *Lackawaxen, Pa. seen from Prospect Rock.*

This 1890 view of Lackawaxen, Pennsylvania, predates the construction of the Zane Grey house. The Delaware and Hudson Canal's Roebling Aqueduct, built in 1848, reflects the need to expand the canal due to increasing business. The Erie Railroad's Lackawaxen River Bridge shows in the foreground, a reminder that the railroad's arrival in 1848 would ultimately doom the canal.

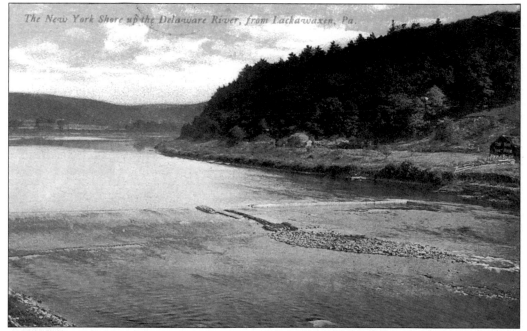

The New York Shore up the Delaware River, from Lackawaxen, Pa.

In 1827, the builders of the Delaware and Hudson Canal erected the only true dam across the Delaware River. The 16-foot-high dam caused many years of problems for lumber raftsmen, recreational canoeists (including the first recorded drowning in 1889), and migrating shad. The footprint of the dam, seen here, can still be seen in the river today, above the Roebling Aqueduct.

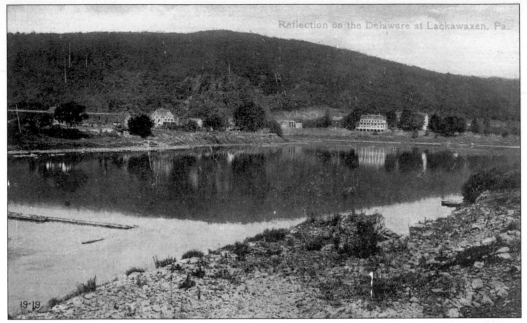

This scene looks upstream at the Lackawaxen pool in Pennsylvania. The large white house (on the left) was the residence of Zane Grey and his family from 1905 to 1918 and is now a museum. Grey's first success as a struggling writer was his story of fishing in the Delaware River. The large hotel (on the right) is the Delaware House. Built in 1852, it was the first hotel in Lackawaxen.

This view from the Delaware House, in Pennsylvania, looks across the mouth of the Lackawaxen River to the Delaware River. In 1779, the Battle of Minisink was fought on the wooded New York hillside seen here. Chief Joseph Brant's band of Native Americans decisively defeated the Colonial troops. One of the Colonial casualties from the battle is buried in Lackawaxen as the Unknown Soldier of the Revolutionary War.

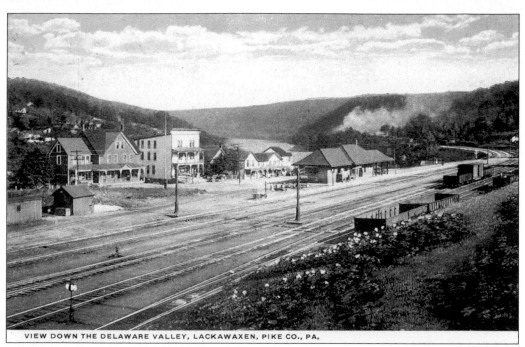

VIEW DOWN THE DELAWARE VALLEY, LACKAWAXEN, PIKE CO., PA.

The Erie Railroad station and several Lackawaxen hotels are seen in this postcard. The railroad laid a branch line to Hawley, Pennsylvania, in 1863. The Wayne County Chamber of Commerce now owns this branch and runs train excursions for tourists. Note the smoke from a steam locomotive working its way up the river valley.

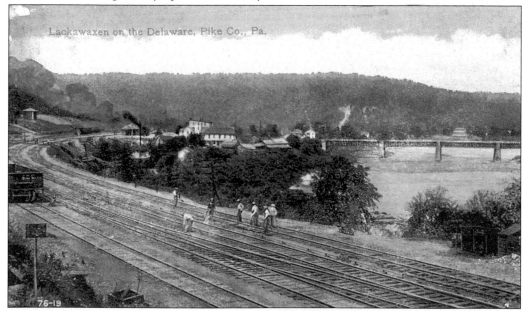

This view of Lackawaxen, Pennsylvania, shows the Roebling Aqueduct. After the demise of the canal, the aqueduct served as a toll highway bridge. In the 1980s, the National Park Service restored the aqueduct, and the original iron cables are still in place. Smoke from two steam locomotives, one of them at the station, and the work crews, suggest the Erie Railroad is catching up on maintenance.

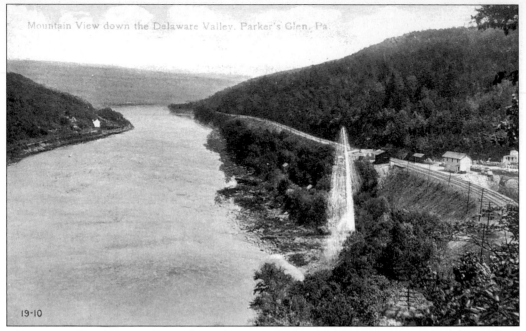

The Erie Railroad ran Walker Lake Falls, an 80-foot waterfall, into a pipe in order to deliver water to the railroad in Parker's Glen, Pennsylvania. The hydraulic head from the fall of the water created this spectacular fountain. John F. Kilgour, the "Bluestone King," founded Parker's Glen in 1875, as a mining community for the Parker-Kilgour Stone Mills. Bluestone, a type of flagstone, was quarried in the upper Delaware for sidewalks and curbing. Stacks of bluestone are seen in the postcard. Today, Parker's Glen is one of several towns on the upper Delaware River that has disappeared.

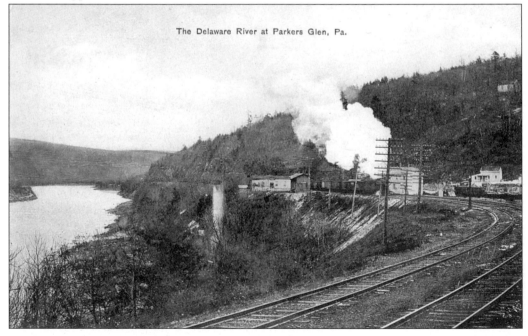

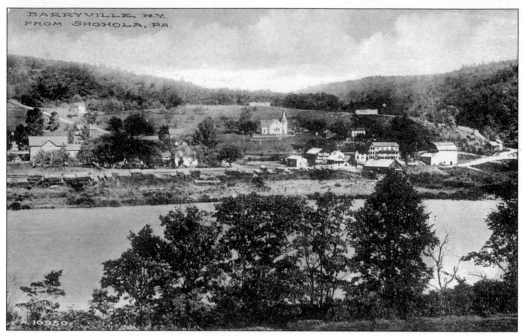

Barryville, New York, lies opposite Shohola, Pennsylvania. The village was founded after the Delaware & Hudson Canal began operating. A boatyard for building and repairing canal boats was located in the town. In 1864, a northbound train carrying 833 Confederate prisoners and their guards collided with a southbound coal train in Shohola, Pennsylvania. Almost 170 people were killed or injured, including two Confederate soldiers who are still buried in Barryville, New York. In the late 19th century, tourists came to Shohola Glen, located along Shohola Creek. The popularity of the glen began interfering with railroad freight operations *c*. 1907. The railroad took action and successfully closed it.

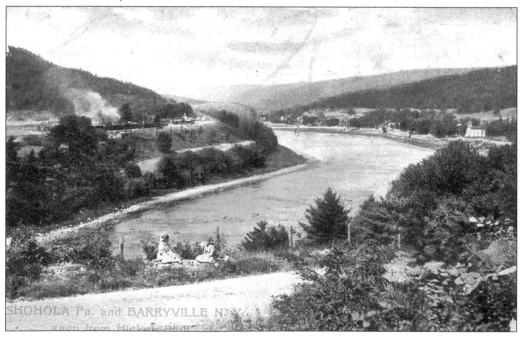

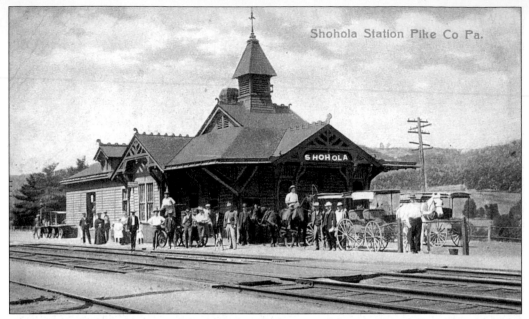

The station at Shohola, Pennsylvania, was certainly one of the most attractive railroad stations along the Delaware River. It was located across the street from the still extant Rohman's Hotel. This hotel (under a different name) and the railroad station served as infirmaries after the disastrous Civil War train wreck.

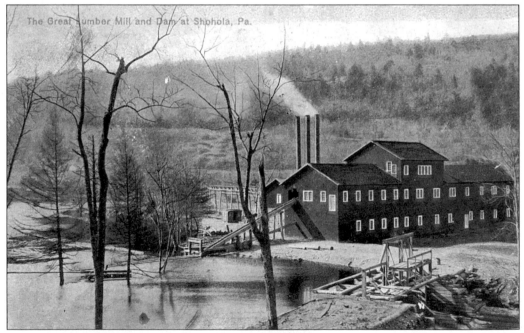

John F. Kilgour, the "Bluestone King," was one of the investors in Shohola Glen. Shohola Glen had a gravity railroad, wooded paths, and natural features like waterfalls and hemlock ravines. After the Erie Railroad closed the Shohola Glen, the Pennsylvania Coal Company erected this sawmill at the entrance. The lumbering operations destroyed both the man-made and natural features of the glen.

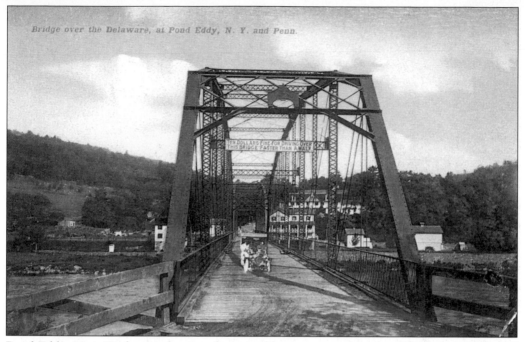

Bridge over the Delaware, at Pond Eddy, N. Y. and Penn.

Pond Eddy, New York, was the site of a major bluestone quarry in the 19th century. The steel bridge in this postcard replaced an 1870s suspension bridge after the 1903 flood. The bridge provided access to a long-gone railroad station in Pennsylvania. In recent years, a debate has ensued over the bridge's removal, with highway officials arguing that maintenance costs are not justified by the few summer homes on the Pennsylvania side.

A trip over Hawk's Nest on today's New York Route 97 is a memorable experience. Numerous automobile television commercials have been filmed on the curvy road over the years. This postcard dates from the time when the road was only a one-lane dirt path. The railroad hugs the Pennsylvania side of the river while the canal is on the New York side, in this view looking north.

31

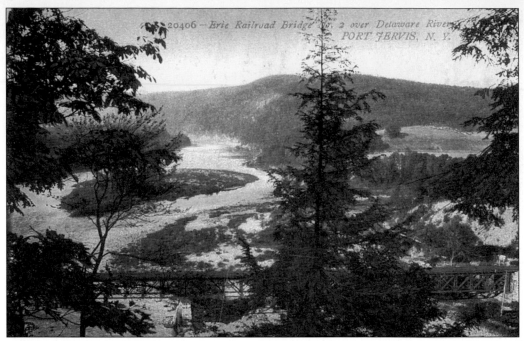

Above Mill Rift, the railroad crosses into Pennsylvania. It then returns to the New York side of the river about five miles below Narrowsburg, New York. Cherry Island and the heights of Hawks Nest are in the distance. The Mill Rift railroad bridge is the southern boundary of the Upper Delaware Scenic and Recreational River.

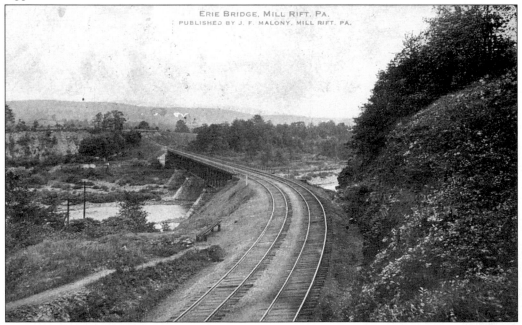

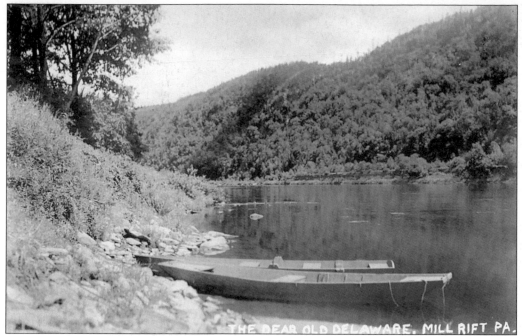

Mill Rift was originally known as Sawmill Rift, named for both for the town's major industry and river feature. In the 19th century, numerous sawmills and bluestone quarries operated in the village and a short-lived boom in hotels and boarding houses followed. The river and scenery found at Mill Rift remains largely unchanged from these postcards. Elephant Feet Rocks (below) are also known as Glass House Rocks, named for a glass factory that once existed above them.

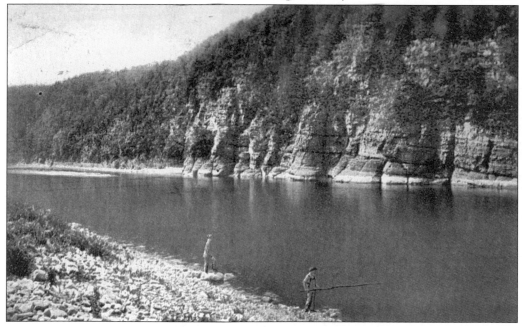

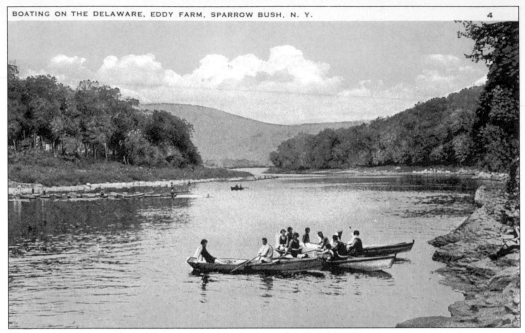

These visitors have rowed across the river from the Eddy Farm Hotel to the rocks on the Pennsylvania side. The hotel began as a typical stopover for lumber raftsmen and evolved into a summer hotel after the Civil War. The Eddy Farm Retreat and Conference Center still exists.

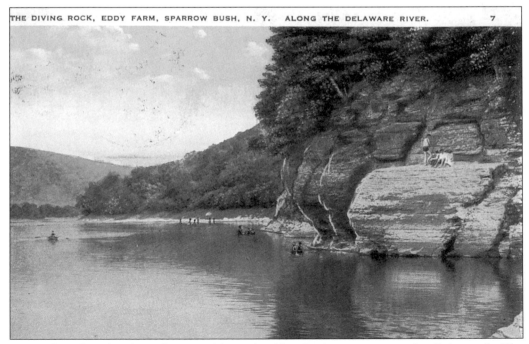

It must be a hot day since there are 14 people either in the water or on the diving rock. The rocks are opposite the Eddy Farm Hotel.

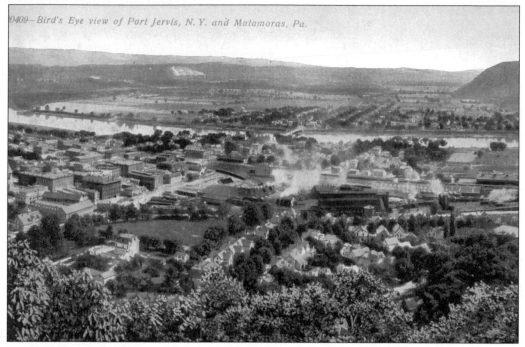

0409—Bird's Eye view of Port Jervis, N.Y. and Matamoras, Pa.

The "port" in Port Jervis was due to the city being a Delaware and Hudson Canal town. Jacob Jervis was the canal's chief engineer. By the 20th century, the majority of the city's employment was with the Erie Railroad. Commuter passenger trains to Hoboken, New Jersey, still serve the town. Its railroad station and roundhouse turntable have been restored in recent years and are worth the trip.

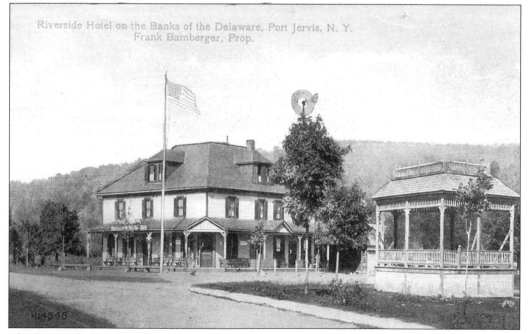

Riverside Hotel on the Banks of the Delaware, Port Jervis, N. Y.
Frank Bamberger, Prop.

The Riverside Hotel, in Port Jervis, New York, was one of the many hotels located along the Delaware River *c.* 1900. Mount William is seen in the background.

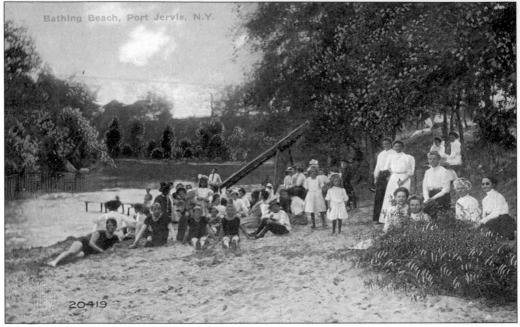

The city of Port Jervis, New York, operates West End Beach, the last municipally owned bathing beach on the Delaware River. This group of mostly non-bathers was enjoying the river *c.* 1900.

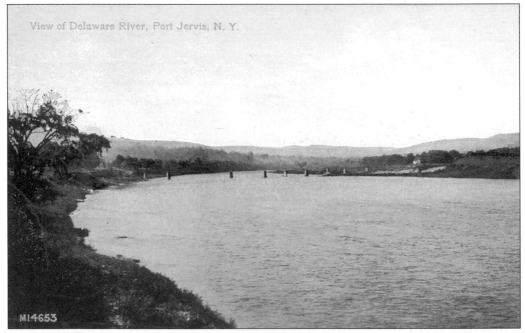

In a view looking upriver, West End Beach, in New York, is shown in the upper right corner. The piers in the river are from a railroad bridge built in 1895 on the piers of an even earlier bridge. The railroad was part of a planned line from Port Jervis, New York, south to East Stroudsburg, Pennsylvania. This section of the proposed line served a stone quarry in Matamoras, Pennsylvania.

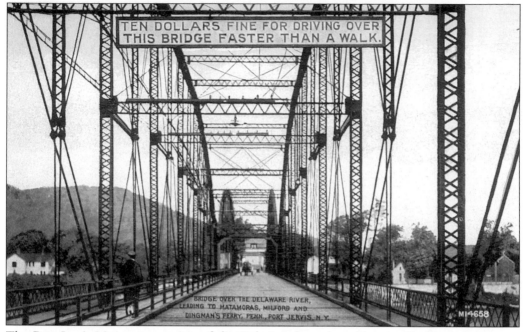

TEN DOLLARS FINE FOR DRIVING OVER THIS BRIDGE FASTER THAN A WALK.

BRIDGE OVER THE DELAWARE RIVER, LEADING TO MATAMORAS, MILFORD AND DINGMAN'S FERRY, PENN., PORT JERVIS, N.Y.

The Port Jervis–Matamoras section of the Delaware has a long history of losing its bridges to Mother Nature. The first bridge between the two towns was built in 1854 and was blown down in 1870 by a violent windstorm. Its replacement, the first Barrett Bridge, was built in 1872, but was destroyed three years later by an ice jam. The second Barrett Bridge survived from 1876 until it was destroyed in the flood of 1903. Shown here is the third Barrett Bridge, which was replaced in 1939. The fourth, and hopefully final, bridge still exists.

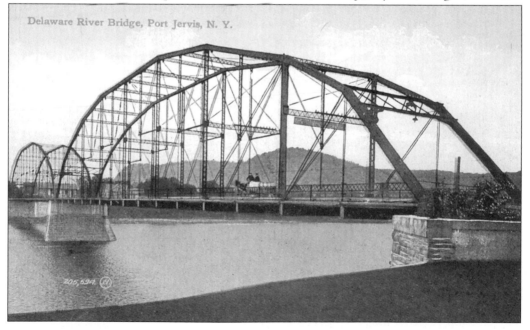

Delaware River Bridge, Port Jervis, N. Y.

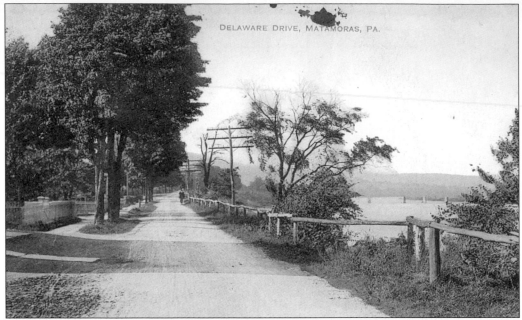

DELAWARE DRIVE, MATAMORAS, PA.

Matamoras, Pennsylvania, is a fair-sized town across the river from Port Jervis, New York. If you cross the Barrett Bridge and turn right immediately, Delaware Drive, shown here, will eventually lead from Matamoras to Mill Rift, three miles upriver. The writer of this card, dated 1908, cautions that, "This card was taken before the dike was built, it don't look much like that now."

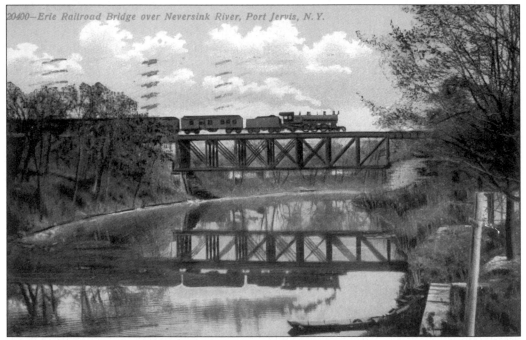

20400—Erie Railroad Bridge over Neversink River, Port Jervis, N.Y.

The Erie Railroad enters Port Jervis and New York by crossing the Neversink River about a half mile above its confluence with the Delaware River. In this postcard, the Delaware can be seen through the trees. If flows were low in the Delaware, early canoeists would disembark at Port Jervis rather than Hancock.

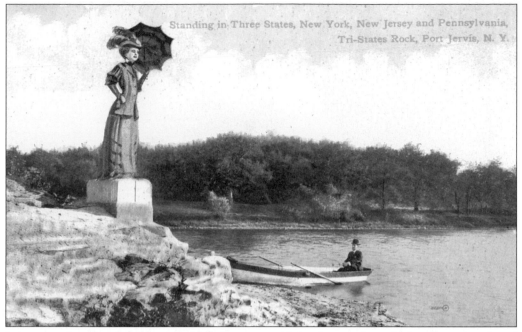

Standing in Three States, New York, New Jersey and Pennsylvania, Tri-States Rock, Port Jervis, N. Y.

It is easy to imagine that this well-dressed woman with her button shoes, high collar, parasol, and ostrich-feather hat was a guest at the Bluff House in Milford, Pennsylvania, or some other notable establishment. Her companion in the elegant rowing skiff, with his suit and bowler, is equally stylish. The woman is standing on Tri-States Monument, the boundary marker at the junction of New Jersey, New York, and Pennsylvania. This is one of 38 locations in the United States where three state boundaries meet. The monument next to the park bench in the postcard below is the witness monument containing the names of the commissioners who set the boundary.

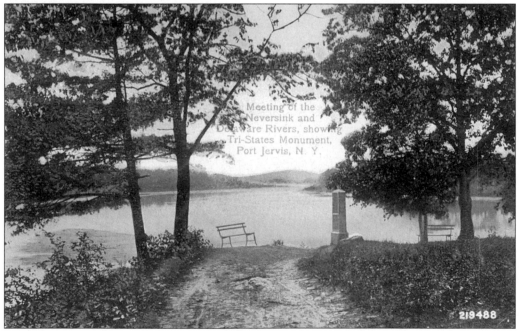

Meeting of the Neversink and Delaware Rivers, showing Tri-States Monument, Port Jervis, N. Y.

219488

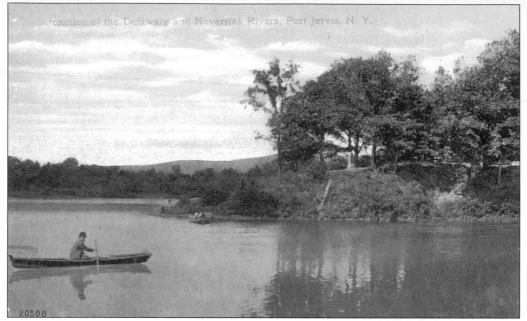

20398

This scene looks upstream toward the Tri–State Monument area, located on the tip of Laurel Grove Cemetery in Port Jervis, New York. Although the shadow of the Interstate 84 bridge and its traffic noise destroy the serenity of this scene today, Tri–State Monument is still worth visiting. The Port Jervis Delaware River Heritage Trail reaches it from downtown.

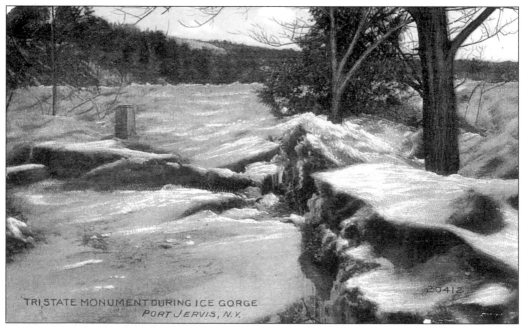

TRI STATE MONUMENT DURING ICE GORGE
PORT JERVIS, N.Y.

20412

Ice jams have been a problem in Port Jervis, New York, for 150 years or more. An ice jam in the river acts like a dam, backing up water and forcing house-sized blocks of ice into developed areas. A variety of solutions have been proposed over the years. Following a 1980s ice jam, the federal government built a relief project downstream from this site. Time will tell if it is successful.

Two

MILFORD, PENNSYLVANIA, TO THE DELAWARE WATER GAP

The middle Delaware is the 43-mile section of river that flows from Port Jervis, New York, through the Delaware Water Gap. Most of the reach is in today's Delaware Water Gap National Recreation Area.

The middle Delaware is slower moving than the upper Delaware. However, many of its tributaries reach the river valley after leaping off mountain plateaus as dramatic waterfalls. These falls, and the river itself, attracted numerous visitors to the region in the 19th and 20th centuries.

Two unique geological features exist on the middle Delaware. The first is Wallpack Bend. At Wallpack Bend, the river reverses direction twice in three miles—at one point, it actually flows north. Shortly after 1900, a series of water-supply dams were proposed for Wallpack Bend, but were never built. In the 1960s, the federal government proposed the large Tocks Island Dam, six miles below Wallpack Bend, but the project did not survive the environmental movement of the 1970s. In 1978, in an effort to keep the dam from being built, Congress designated the portion of the river within the national recreation area as the Middle Delaware Scenic and Recreational River.

The Delaware River breaks out of the mountains when it flows through the Delaware Water Gap, the second unique geological feature. The gap, and surrounding region, was one of the leading vacation resort areas in the United States c. 1900.

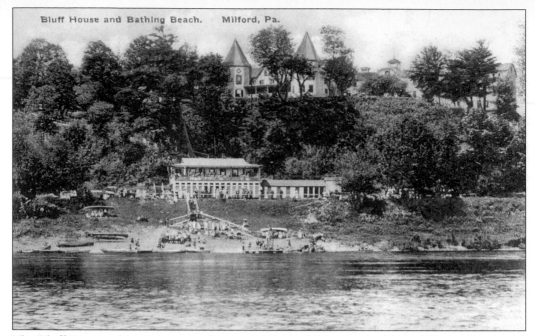

Bluff House and Bathing Beach. Milford, Pa.

The Bluff House (above) was one of many similar establishments in Milford, Pennsylvania, and elsewhere, that catered to summer visitors. Although the buildings burned down, the site of the hotel can still be found on the bluff. The unusual panoramic postcard (below) shows the relationship of the hotel complex and the river. Sawkill Creek (far left) and Vandermark Creek (right) can be seen entering the river. Special hand-cranked or motorized cameras were used to take photographs like this one.

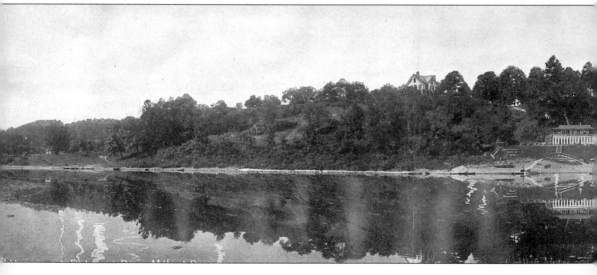

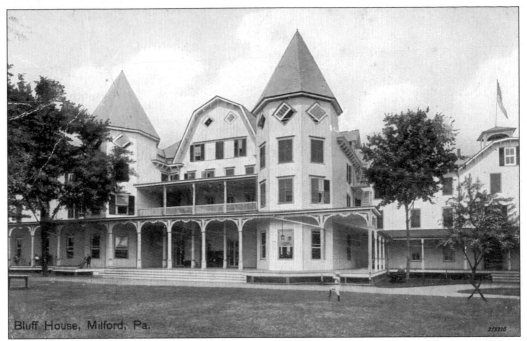

Bluff House, Milford, Pa.

A close-up of the Bluff House shows the elegance of the old wooden resort hotels. The little boy in his white outfit, complete with cap and knickers, almost blends into the hotel. The white outfit must impede his fun.

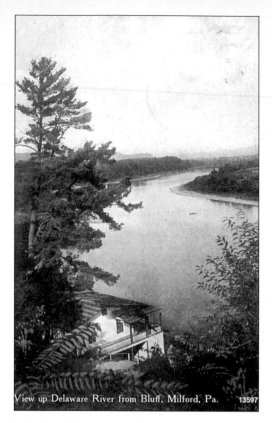

View up Delaware River from Bluff, Milford, Pa. 13597

This view of the river entering the pool area in Milford, Pennsylvania, was taken from the gazebo that stood on the grounds of the Bluff House. This was a favorite stopping place for lumber raftsmen. For those who did not stop, a rowboat selling swigs from a jug of applejack visited the rafts below town.

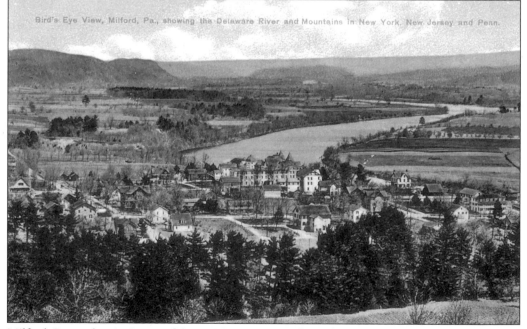

Bird's Eye View, Milford, Pa., showing the Delaware River and Mountains in New York, New Jersey and Penn.

Milford, Pennsylvania, is one of the prettiest towns on the Delaware River. This aerial view looks north toward Matamoras, Pennsylvania, and Port Jervis, New York.

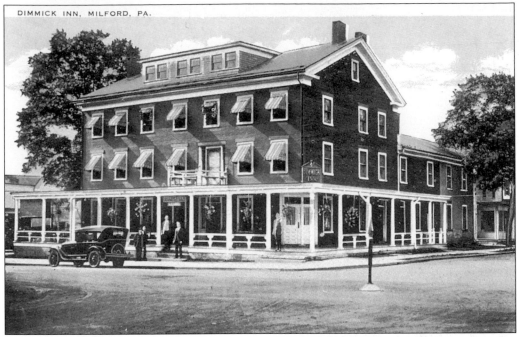

Dimmick Inn has been in downtown Milford, Pennsylvania, for more than 175 years. Due to restorations by the current owners, it now closely resembles the inn from this postcard.

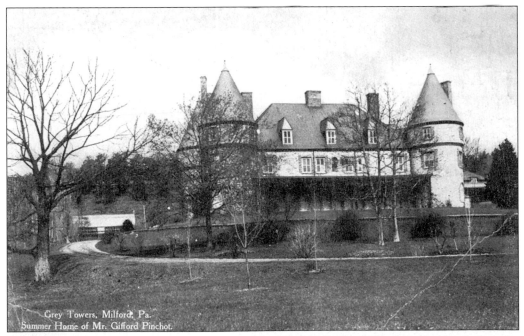

Grey Towers was the elegant summer home of the Pinchot family. Gifford Pinchot headed up the forest service created by Pres. Theodore Roosevelt and is considered the father of American conservation. He later served as governor of Pennsylvania. Grey Towers is now open to the public.

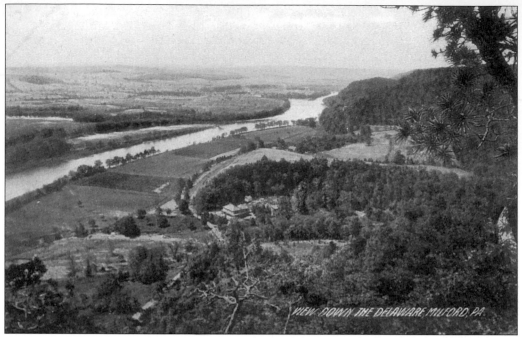

In this postcard, the Delaware River valley is seen from the cliffs south of Milford, Pennsylvania. The building below is the Hotel Schanno, or Shanna House. In the early part of the 20th century, the hotel was famous for its fine cuisine. The federal government acquired the historic hotel building in the 1970s, but it was destroyed by arson in 1990.

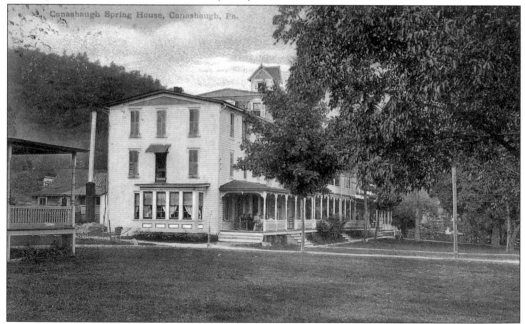

Downstream from the Shanna House was the Conashaugh Spring House. This hotel began in 1837 as rafter's hotel and converted to the summer trade in the 1870s. In the 1890s, the hotel's owners ran telephone lines from the hotel to the train station in Port Jervis, New York, establishing one of the earliest telephone companies in Pennsylvania. The hotel burned down in 1915.

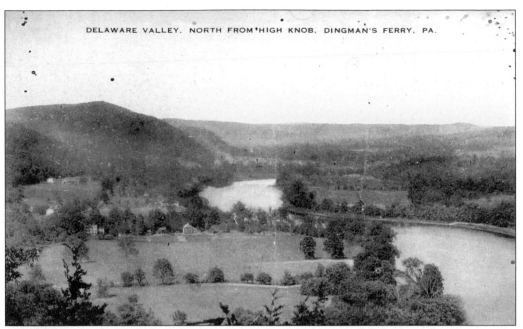

Rural Minisink Valley, between the Delaware Water Gap and Port Jervis, New York, can be seen in this upstream view. The river flats were extremely productive farmland. This, plus the lack of railroads that would need relocating, made this area a prime target for the development of a reservoir. The huge Tocks Island Dam project of 1960 to 1975 was the last of many proposals since the 1920s.

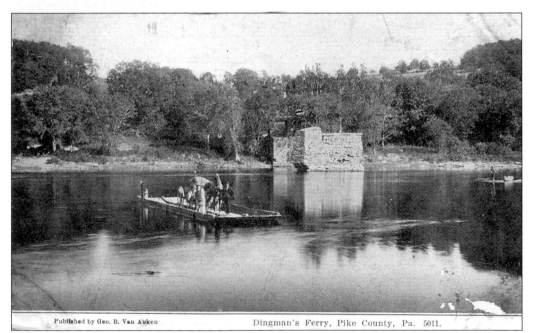

Published by Geo. B. Van Auken Dingman's Ferry, Pike County, Pa. 5011.

The Dingman family operated a ferry at this site from 1735 until 1836, when they replaced it with a bridge. Three bridges had come and gone by the time this 1896 photograph was taken. The fourth bridge opened in 1900 and still exists as the last privately owned toll bridge on the Delaware.

47

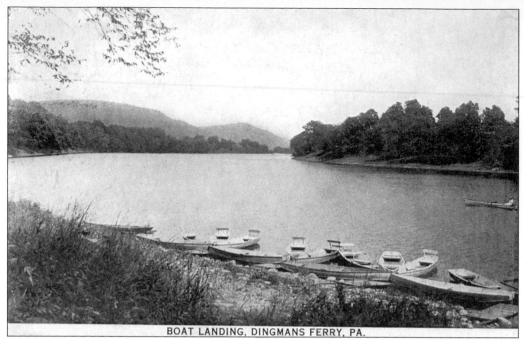

BOAT LANDING, DINGMANS FERRY, PA.

This postcard, with a view looking upstream, was published by the High Falls Hotel in Dingmans Ferry, Pennsylvania, and was mailed in 1916. The hotel was built in 1812. Traditional rowing boats were common on the Delaware River until the 1950s, but are rarely seen today. Note the fine examples of boatbuilding at the landing.

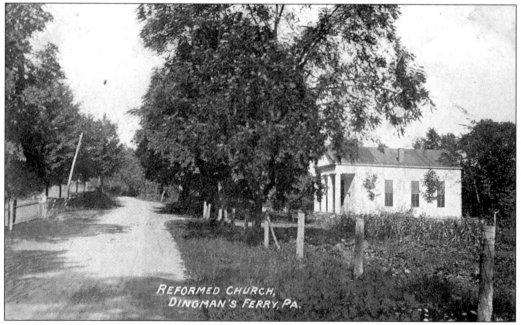

REFORMED CHURCH, DINGMAN'S FERRY, PA.

Dingmans Ferry, Pennsylvania, was a real village until the mid-1970s, when federal land acquisition for the Tocks Island Dam project resulted in its demise. The Dutch Reformed Church, from 1851, is one of the few survivors. The church now exists as Phoenix, a retail store selling southwestern items.

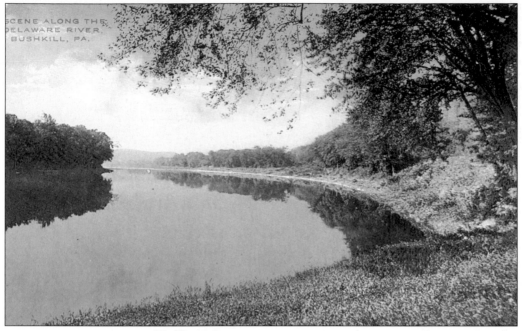

Two views are shown of the Delaware River in the vicinity of today's Bushkill River Access Area. Although much has changed in the area, the river looks essentially the same today. Anna, who was visiting from New York City, sent the card below to her friend Max in 1912. She wrote, "We have plenty of fun here. Today I milked a cow."

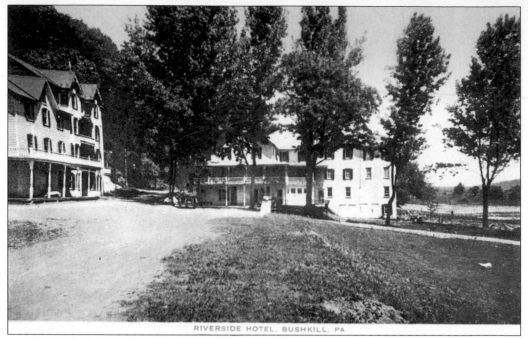

RIVERSIDE HOTEL, BUSHKILL, PA

The Riverside Hotel was located several miles above Bushkill, Pennsylvania, near the location where the Bushkill River Access Area is today. The hotel originally serviced lumber rafters, but expanded in the late 19th century.

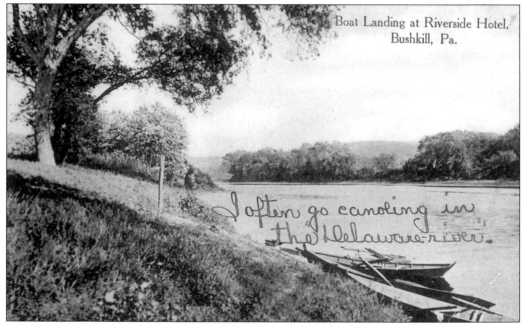

Boat Landing at Riverside Hotel, Bushkill, Pa.

I often go canoeing in the Delaware river.

This section of the future U.S. Route 209 is north of the former village of Bushkill, Pennsylvania. When bicycles became the craze in the 1890s, clubs from the large cities journeyed to the area to ride on roads like this one. Today, the road is paved and patrolled by National Park Service rangers.

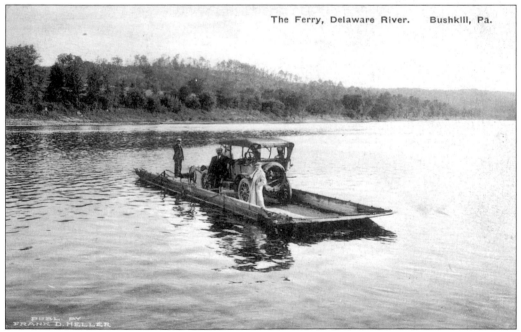

The Rosenkranz ferry began operating at this location in 1898. The cable ferry saved considerable time for New Jersey residents heading to Stroudsburg, Pennsylvania, to shop. Allegedly, the general public was charged 35 cents per automobile, but Rosenkranz neighbors paid only 25 cents. When operation ended in 1945, the ferry was the last of its kind on the Delaware.

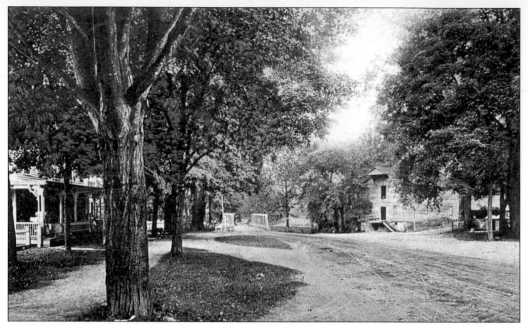

Bushkill, Pennsylvania, is another village that has largely disappeared in the last 30 years. On the left, a corner of the porch of the Peters House can be seen. To the right of the bridge, over Bushkill Creek, is the historic gristmill that dated back to the 1700s. The mill survived the would-be Tocks Island Dam project builders, only to be destroyed by arson in 1980. Trees to the right of the mill hide the general store.

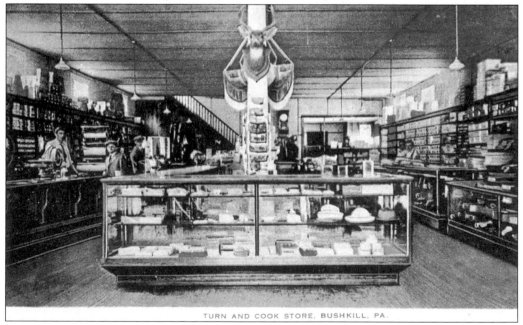

TURN AND COOK STORE, BUSHKILL, PA.

The Turn and Cook store in Bushkill, Pennsylvania, still exists after more than 100 years. The store has had various owners, but "Turn and Cook" is still embedded in mosaic on the front stoop. Although the interior now resembles a modern convenience store, visitors can still feel the essence of the original store.

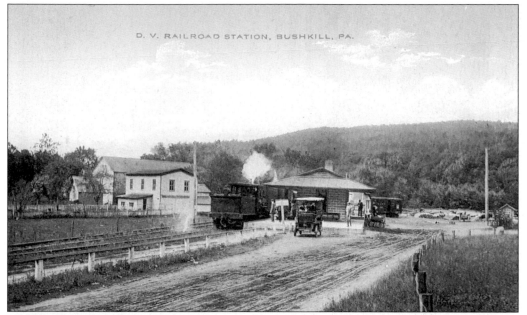

The tiny Delaware Valley Railroad connected Bushkill, Pennsylvania, to East Stroudsburg, Pennsylvania, from 1901 to the 1930s. The line hauled wood, ice from the ponds en route, other freight, and passengers heading to various hotels. The Bushkill station is gone, but the Marshalls Creek station down the line still exists.

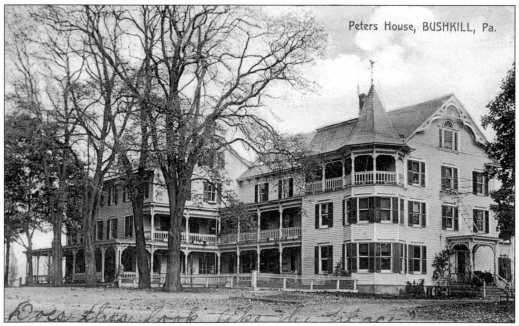

At least three generations of Peters were involved with this site. Henry operated a tavern here sometime after 1819. In 1860, his son, Charles, tore down the tavern and built the Bushkill Hotel—the middle section of the hotel as seen here. Later, grandsons Harry and Edwin enlarged the original hotel and renamed it the Peters House. It was torn down in 1972 for the pending dam project.

Old Friends Along the Delaware, Bushkill, Pa.

This postcard shows the beginning of the upstream bend of Wallpack Bend. Wallpack Bend is an S-curve, created by a ridge that turns the river from its southerly direction. Wallpack Bend is a good location for a dam, and numerous projects were proposed before the Tocks Island Dam project was authorized.

DELAWARE CLIFF CAMPS FLATBROOKVILLE, N. J.

These overturned wooden canoes are on the downstream curve of the Wallpack Bend S-curve. The river is now heading south again after temporarily flowing north. The curved lines drawn on the sides of the canoes indicate that they have sponsons, air chambers of wood built on the outside of the hull. Sponsons make the canoes virtually unswampable and were a favorite of children's camps.

54

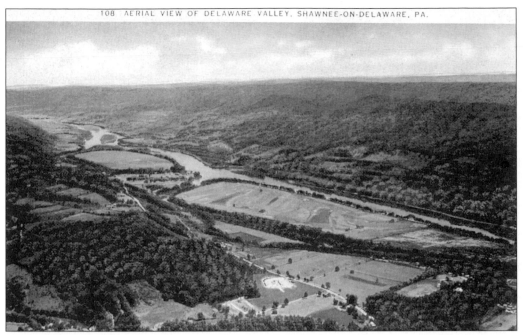

In a view looking upstream, New Jersey is on the right and Pennsylvania on the left. The upper islands in this scene are Tocks Island followed by Labar Island, immediately downstream. Depue and Shawnee Islands are also shown hugging the Pennsylvania shore. The huge dam proposed for Tocks Island would have been the Corps of Engineers' biggest project east of the Mississippi.

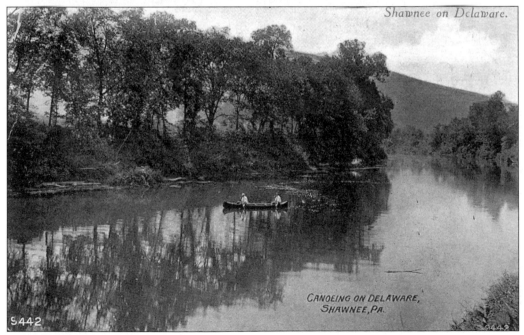

This bucolic river scene was probably photographed on the back channel of Depue Island as it approaches the Buckwood Inn, later the Shawnee Inn. Thousands of people canoe this same location each year.

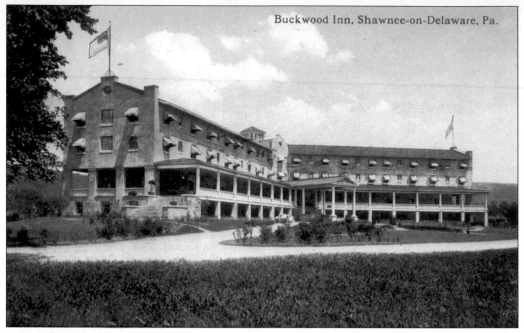

Buckwood Inn, Shawnee-on-Delaware, Pa.

Industrialist Charles C. Worthington opened the Buckwood Inn in 1911. Unlike most other hotels of the era, it was made of concrete and was fireproof. In 1912, the Professional Golfers Association (PGA) was founded at the resort and the first PGA tournament was held. From 1943 to 1974, the famous bandleader, Fred Waring, operated the hotel, now called the Shawnee Inn.

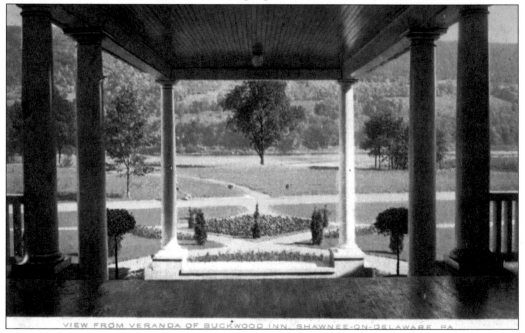

VIEW FROM VERANDA OF BUCKWOOD INN, SHAWNEE-ON-DELAWARE, PA

Charles C. Worthington acquired 6,500 acres across the Delaware River in adjacent New Jersey. This preserve was available to guests of the Buckwood Inn for hiking, sightseeing, picnic parties, or just enjoying from the front porch, as seen here. The Worthington family sold its New Jersey property to the state in 1954. Today, it is Worthington State Forest.

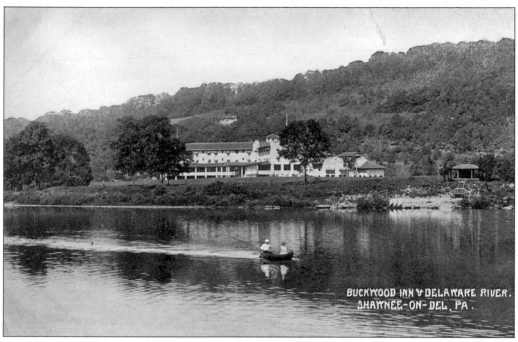

The message on this view of the Buckwood Inn says, "It is perfect up here. . . . We had a fine auto trip, only one puncture. Weather is ideal, golf course one of the best in the country."

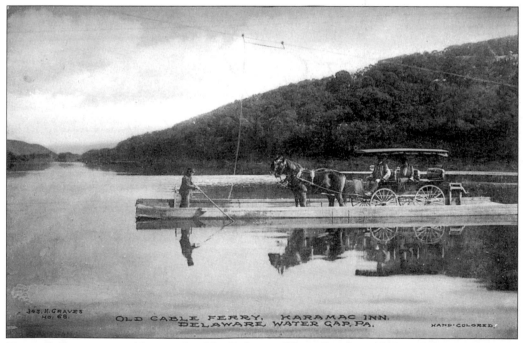

Transue's Ferry operated just north of the Delaware Water Gap from 1882 until the 1930s. It was a private ferry used to transport visitors between the railroad in Pennsylvania and the Fairview House (later the Karamac Inn) in New Jersey. In 1966, the federal government acquired the inn. Later, it was destroyed by arson and replaced with a parking lot.

BRIDGE OVER THE RIVER AT DELAWARE WATER GAP, PA.

The New York, Susquehanna, and Western Railroad built this bridge across the Delaware when the line extended to Stroudsburg, Pennsylvania, in 1882. The bridge is located immediately upstream from the Delaware Water Gap. The "Susie Q" operated trains across the bridge until 1941. Today, hikers along the short trail will discover mileage markers, bridge piers in the river, and the site of the Karamac, New Jersey, ferry landing.

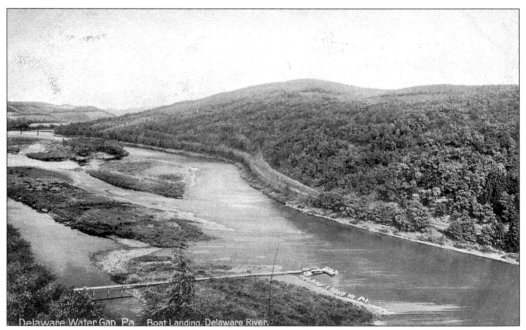

Delaware Water Gap. Pa. Boat Landing. Delaware River.

In a view looking upriver from the Delaware Water Gap, the New York, Susquehanna, and Western Railroad's bridge appears at the top. In the foreground is the long ramp to the boat landing. The Interstate 80 bridge cuts across the middle of this view today.

58

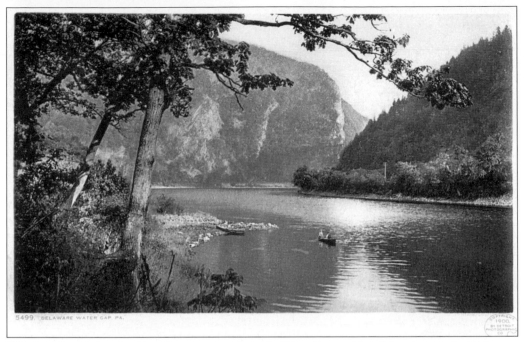

This is a classic view looking downstream from the New Jersey side of the river at the Delaware Water Gap. The gap is 1,300 feet deep and was once promoted as the "Eighth Wonder of the World."

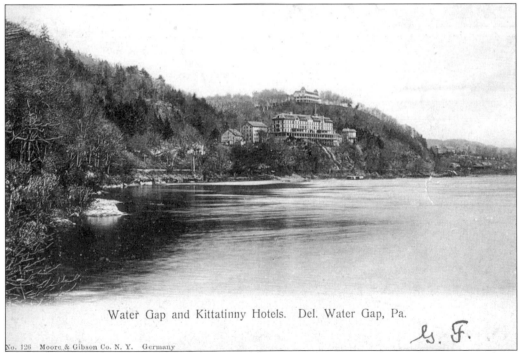

Water Gap and Kittatinny Hotels. Del. Water Gap, Pa.

In the heyday of the water-gap hotels, the view of the hotels was almost as impressive as the gap. On the upper ridge is the Water Gap House, and directly below it is the Kittatinny House. The Delaware Water Gap train stations and several other establishments are barely visible on the right.

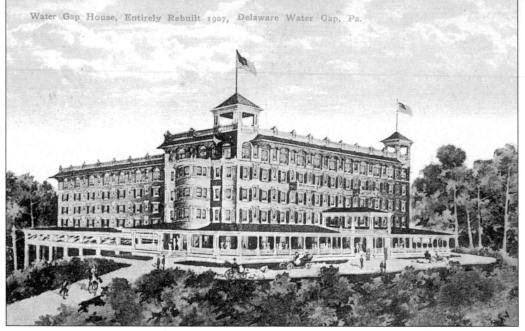

Water Gap House, Entirely Rebuilt 1907, Delaware Water Gap, Pa.

The Water Gap House literally looked down on all the other water gap hotels. The hotel was opened in 1872, was rebuilt in 1907, and burned down in October 1915. A series of walking trails led from the hotel to various scenic sights, including the top of the gap itself. Pres. Theodore Roosevelt was one of many famous visitors. However, not everybody enjoyed the hotel. In 1884, a group of Albany, New York, canoeists climbed the mountain to visit the establishment, only to find it was alcohol free. Alcohol or not, the dining experience in the Water Gap House must have been extraordinary with the view of the mountains and the river below.

WATER GAP HOUSE GRILL, DELAWARE WATER GAP, PA.

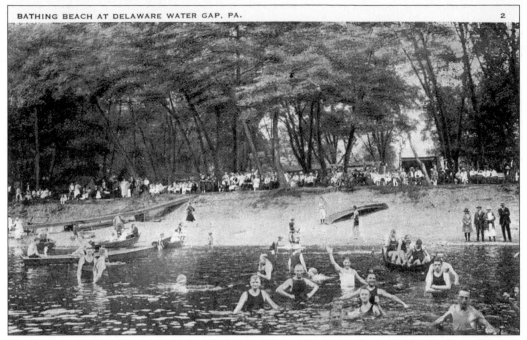

The best place for swimming in the Delaware Water Gap is on the New Jersey shore (above). The National Park Service visitor center is located here today. In the top scene, at least 100 people are enjoying the water either directly or vicariously. Except for the fashion and a few other details, this scene is still repeated every summer weekend. The second scene (below) captures the grandeur of the gap. Note the little steam launch paying a visit to the dock.

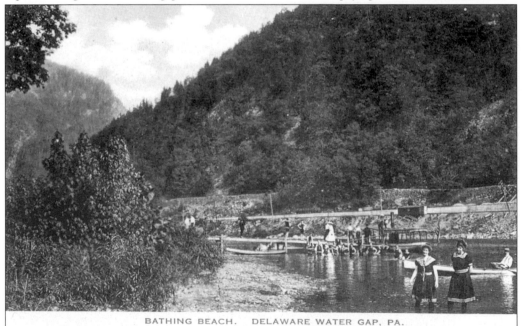

BATHING BEACH. DELAWARE WATER GAP, PA.

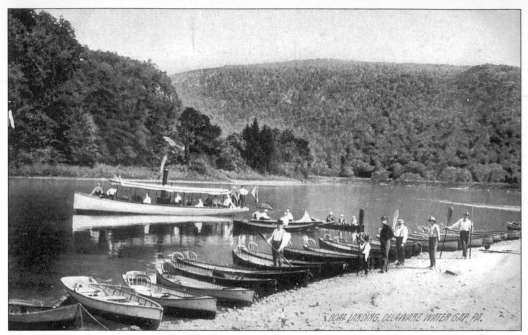

The Kittatinny House maintained a fleet of rowboats that could be hired with or without a rower. The rowboat and its passengers floated through the gap observing the scenery. At the lower end of the trip, various places of interest could be hiked to, including the top of the gap itself. The gap could also be traveled in the hotel's steamboat, the *Kittatinny*. It arrived in May 1879, under its own power, from Bristol, Rhode Island. Although it made trips as far north as Port Jervis, New York, the boat was used mainly within the Delaware Water Gap and its environs. In 1899, it was replaced with the *Kittatinny II*, shown above. The smaller launch, below, possibly named the *Minnihaha*, joined it in 1888.

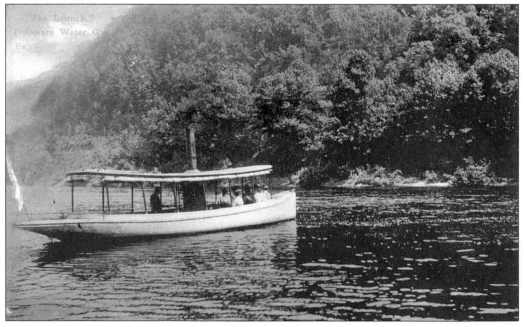

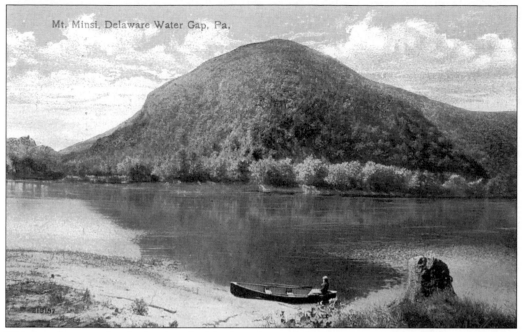

This location was the destination for hired rowboats and other cruises in the water gap. Off the point of Mount Minsi, on the Pennsylvania side of the gap, the river is 45 feet deep. Freight cars from a Delaware, Lackawanna, and Western Railroad train that derailed while passing through the gap lie at the bottom. Today, the roar of Interstate 80 dominates this location.

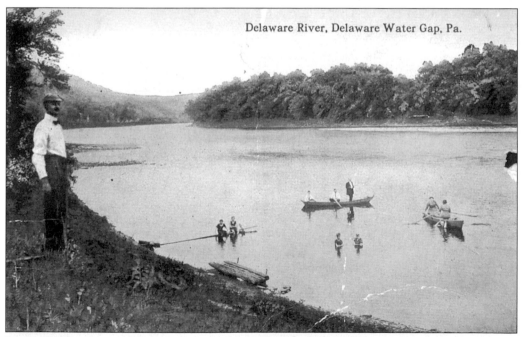

Recreation in the era of summer hotels could be quite formal. The man standing on shore has on a white shirt and bow tie while the three men in the boat are wearing neckties.

63

After a hard day of floating through the water gap and rowing back, it was time to relax. In the days before air conditioning, places like this summerhouse were preferable to being indoors. The River View House was near the location of today's Interstate 80 toll bridge.

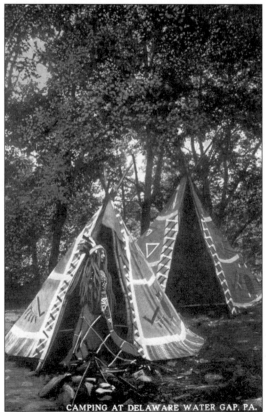

CAMPING AT DELAWARE WATER GAP, PA.

This postcard is dated 1914, but the details of the Native American camp are not known. This imaginative camping scene probably represents something provided for family entertainment. The Delaware Indians, who originally resided along the river, would not have recognized this style of camp because it is more typical of the Plains Indians.

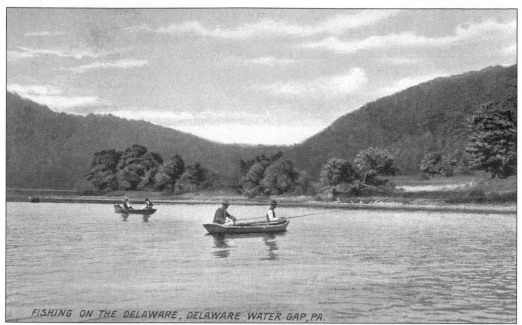

FISHING ON THE DELAWARE, DELAWARE WATER GAP, PA.

The Delaware River has always provided good sportfishing. The river is literally fished day and night and in every season. City folks, whose local rivers had become too polluted for fishing by the end of the 19th century, welcomed vacations spent in boats like these.

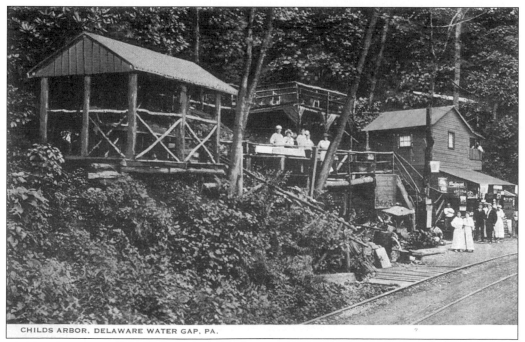

CHILDS ARBOR, DELAWARE WATER GAP, PA.

Childs Arbor was a series of footpaths and shelters in Eureka Glen. This water gap attraction was located in Pennsylvania and easily reached by trolley. George W. Childs, a Philadelphia publisher, developed it for the resort trade, and the attraction evolved into a typical tourist trap and hot-dog stand that lasted into the 1960s.

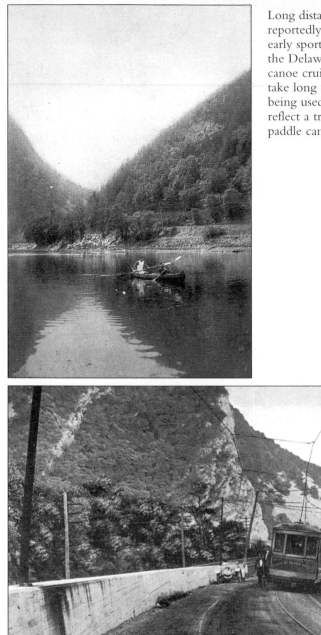

Long distance canoe cruising, like the kind reportedly shown here, was a major part of the early sport of canoeing. Beginning in 1876, the Delaware River served as an outlet for canoe cruisers who did not have the time to take long excursions. The double paddles being used here with a tandem, open canoe reflect a transition from the solo, double-paddle canoes of the 19th century.

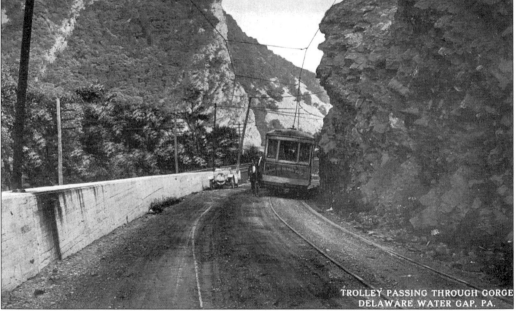

TROLLEY PASSING THROUGH GORGE
DELAWARE WATER GAP, PA.

Virtually anybody could afford to visit the Delaware Water Gap. While most came by train, trolley service was cheaper. The Delaware Valley Route from Philadelphia, for example, only cost $2.40 for a round-trip ticket. It involved six companies, five changes of cars, and six hours of riding. The last leg of the trip was a Stroudsburg, Water Gap, and Portland Street Railway trolley, shown here.

Three

THE DELAWARE WATER GAP TO TRENTON, NEW JERSEY

The 78-mile section of river that flows from the Delaware Water Gap to the head of tide at Trenton, New Jersey, is known as the lower Delaware River. After the gap, the valley broadens considerably and the adjacent hills do not dominate the landscape as much as the mountains farther north.

The lower Delaware corridor was very much an active participant in the industrial revolution. Although the region was also agriculturally important, large industrial facilities dotted the riverbanks of even the smallest towns. Heavy industries—like American Sheet Iron Works, Tippett and Wood Steel Works, Andover Furnace, and Glendon Iron Company—were located in Easton, Pennsylvania, and Phillipsburg, New Jersey. Cement mills were found in Martins Creek, Pennsylvania, and paper mills were found in Riegelsville, Milford, and Frenchtown, New Jersey, and in New Hope, Pennsylvania. Lambertville, New Jersey, had two rubber plants, a hairpin factory, and a toilet factory. Trenton, New Jersey's slogan, "Trenton Makes, the World Takes," reflected its importance as a manufacturing center.

By 1900, seven major railroads and five canals intersected the Delaware River in some manner, making it an important transportation corridor. The railroad industry was a major employer. The lower Delaware also provided places to escape from the industrial landscape, and smaller hotels and boarding houses that catered to vacationers could be found in most towns.

The lower Delaware remains a historic and scenic river corridor. Congressional designations include the Delaware and Lehigh National Heritage Corridor in 1988 and the Lower Delaware Scenic and Recreational River in 2000.

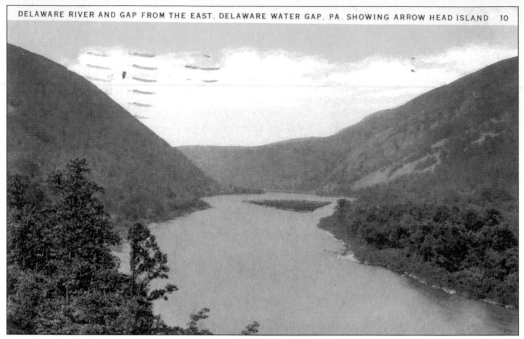

Arrow Island is immediately downstream from the Delaware Water Gap. The island is the boundary between the Delaware Water Gap National Recreation Area and the Lower Delaware Scenic and Recreational River.

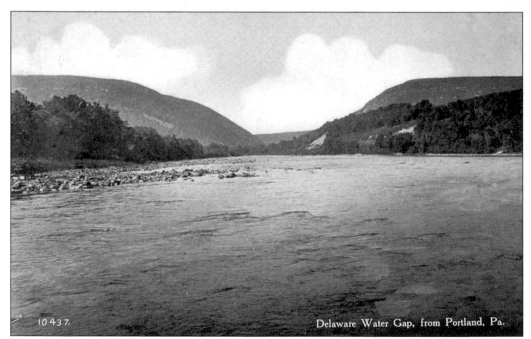

About a mile and a half below Arrow Island, the change in relief is more noticeable as the river breaks out of the mountains.

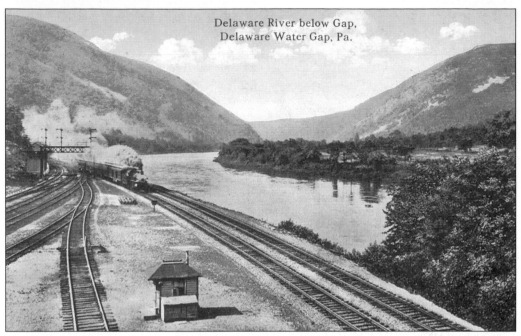

Delaware River below Gap,
Delaware Water Gap, Pa.

The Delaware, Lackawanna, and Western Railroad crossed New Jersey and the Delaware River before heading upstream. This southbound passenger train is at Slateford Junction near Portland, Pennsylvania. The Pennsylvania Railroad also used this line to reach the Delaware Water Gap area from Trenton, New Jersey.

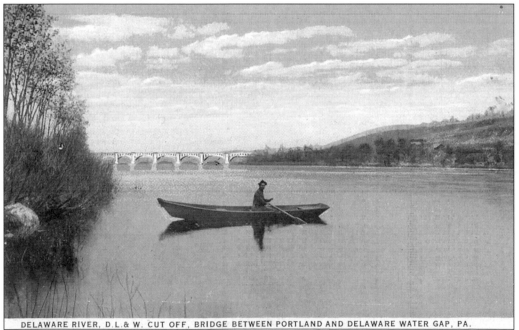

DELAWARE RIVER, D.L.& W. CUT OFF, BRIDGE BETWEEN PORTLAND AND DELAWARE WATER GAP, PA.

The white bridge in the distance is the Delaware, Lackawanna, and Western Railroad's concrete Delaware River Viaduct, built in 1911 and still standing. Prior to the bridge, all the trains crossed the river four miles downstream. While several railroads served the Delaware Water Gap resort industry, their main business in the gap was hauling coal and other freight.

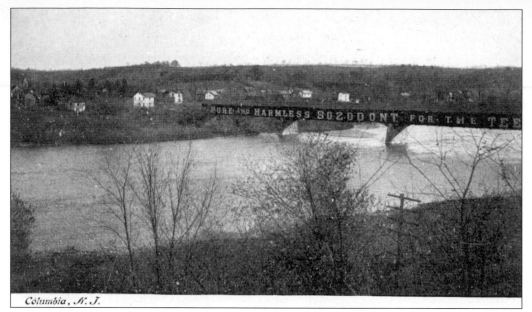

Columbia, N. J.

The 775-foot-long Columbia-Portland covered bridge was completed in 1869. By 1953, when a new bridge replaced it, the old bridge was considered the longest covered bridge in the world. The covered bridge served as a footbridge until destroyed by the 1955 flood. A post-1955 footbridge crosses the Delaware today on the original bridge piers. In this view, the side of the bridge advertises "Sozodont for the Teeth."

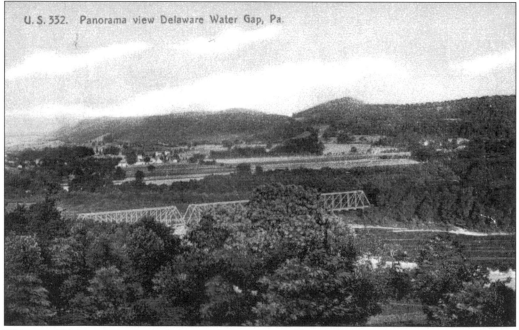

U. S. 332. Panorama view Delaware Water Gap, Pa.

This pre-1914 scene near Delaware, New Jersey, looks north into the state. The Delaware, Lackawanna, and Western Railroad bridge, seen here, was replaced in 1914 with a new one a short distance upstream. Henry Darlington purchased the bridge and converted it into a highway toll bridge.

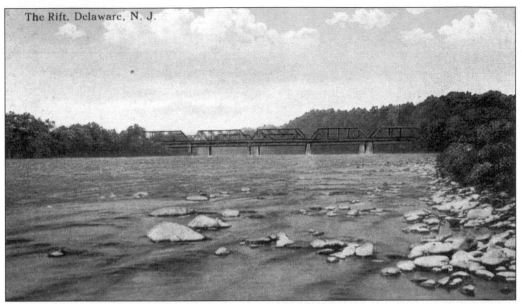

This post-1914 view shows the Darlington toll bridge from water level. Henry Darlington—an Episcopalian minister with several congregations in the Delaware, New Jersey, area—sold the bridge to the interstate bridge commission in 1932. It was dismantled in 1954. The new railroad bridge can be seen behind the toll bridge.

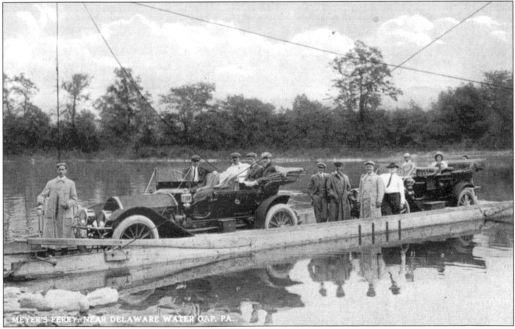

The Meyers Ferry operated less than a mile downstream of the Darlington toll bridge. It began in 1887, mainly to connect hotels in Pennsylvania with the railroad in Delaware, New Jersey. An accident in 1912, however, killed four people. After that, the shrewd Reverend Darlington purchased it cheaply and closed it.

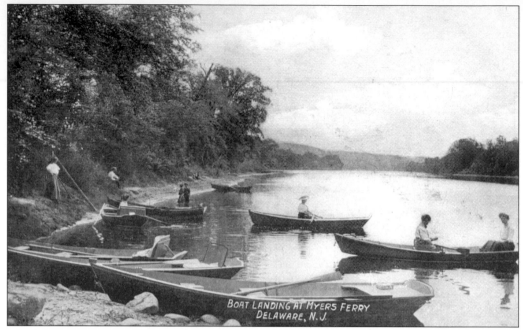

This scene at the Meyers boat landing shows a party of women. The eight rowboats are especially interesting because they reflect the craftsmanship of a builder whose work does not appear at other locations. The origins of the various local Delaware River rowboats is an interesting subject that has not been researched.

Below the Delaware Water Gap, the river valley is farm country. This view, believed to be south of Delaware, New Jersey, looks north. The many pumpkins that grow on river flats such as these are still an interesting sight each fall. In October 1903, a severe flood, known ever after as the Pumpkin Flood, sent thousands of pumpkins downriver.

View of Delaware River, Belvidere, N. J.

This postcard scene is likely upstream of Belvidere, New Jersey. While vacationers naturally gravitated to the region above the Delaware Water Gap, the flatter terrain along the rest of the river is no less scenic than the mountainous terrain in the north.

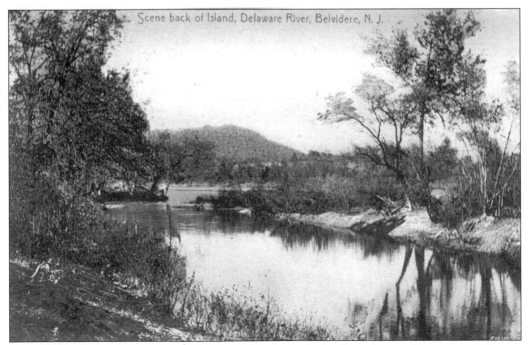

Scene back of Island, Delaware River, Belvidere, N. J.

This back channel is probably behind Mack Island. Back channels are always interesting to explore because of the slower moving water and closer contact with nature.

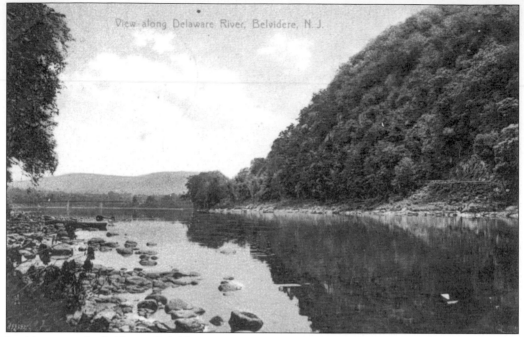

In this scene, the bridge at Belvidere, New Jersey, appears downstream. Pennsylvania is on the right and New Jersey on the left. During the first half of the 20th century, numerous hydropower dams were proposed across the river immediately upstream of Belvidere. A major legal impediment that likely affected financing was the 1783 New Jersey-Pennsylvania anti-dam treaty.

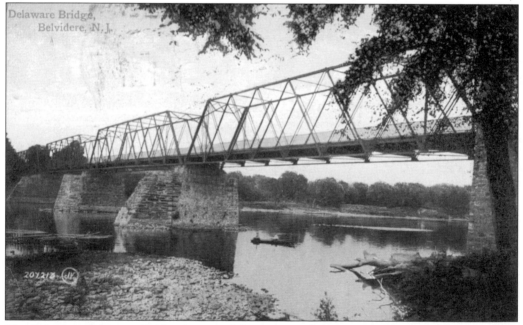

The Belvidere-Riverton Bridge is one of the many Delaware River bridges built in 1904 to replace those lost in the October 1903 flood. A ferry crossing at this site dates to 1800 or earlier and the first bridge was c. 1836. Many of the post-1904 bridges across the Delaware actually sit on piers that are at least 150 years old.

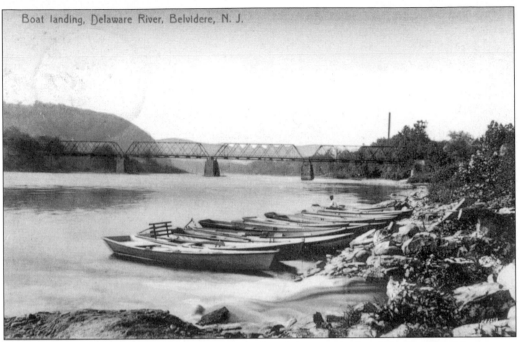

Boat landing, Delaware River, Belvidere, N. J.

This boat landing was downstream of the Belvidere-Riverton Bridge. The Pequest River enters the Delaware in the short reach between the foreground and the bridge. The tributary's discharge can be seen as a frothy area. A bathing area existed immediately below the bridge.

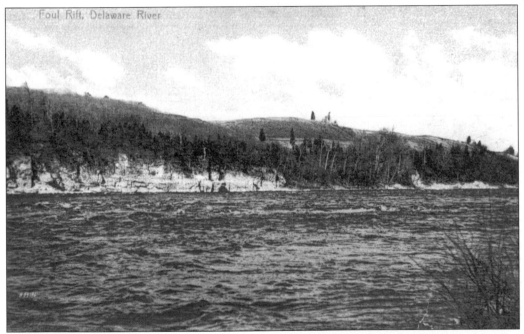

Foul Rift, Delaware River

Foul Rift is one of the most dangerous rapids on the Delaware. It was a severe hazard to lumber rafts, Durham boats, coal arks, and other commercial craft that used the river. In 1791, Pennsylvania contracted to remove some of the worst rocks in the rapid, but most of the rocks remained after the job was done.

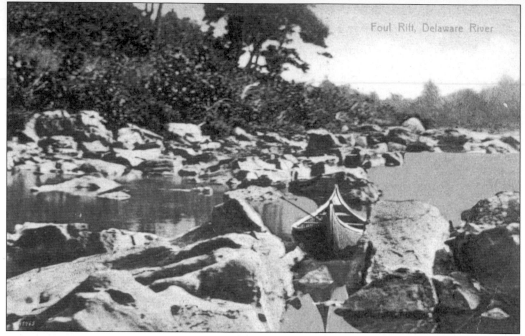

The setting of this beautiful wood and canvas canoe illustrates the rock garden at Foul Rift. The real problem rocks in the rapids, however, are those just below the water surface. If a boat makes it though all the rocks, the last obstacle of the rift is a ledge with a three-foot drop.

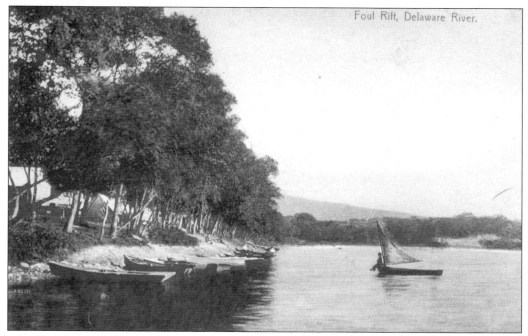

The peacefulness of this scene belies the dangers upstream. The skiff here is interesting in its own right, since pictures of sailing are rare in the non-tidal river. Today, this location has a cottage community to the left and a large power plant with two tall cooling towers to the right.

View along the Delaware Road, looking North, Easton, Pa.

These two views of Delaware River Road, north of Easton, show the road that became Pennsylvania Route 611. This road leaves the Delaware River and winds north through farmland and Pennsylvania's slate-belt region before rejoining the river at Portland for the trip up through the Delaware Water Gap.

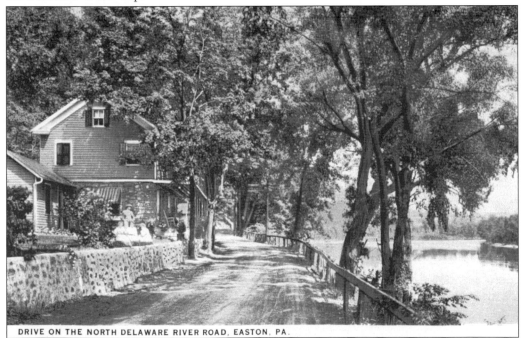

DRIVE ON THE NORTH DELAWARE RIVER ROAD, EASTON, PA.

View on the Delaware, near Easton, Pa.

The Delaware River actually has other water gaps, including Weygadt Gap, located about three miles upstream of Easton, Pennsylvania. These two views looking downstream show Marble Mountain (708 feet) on the left and Chestnut Hill (700 feet) on the right. An overlook for this gap is located along Pennsylvania Route 611.

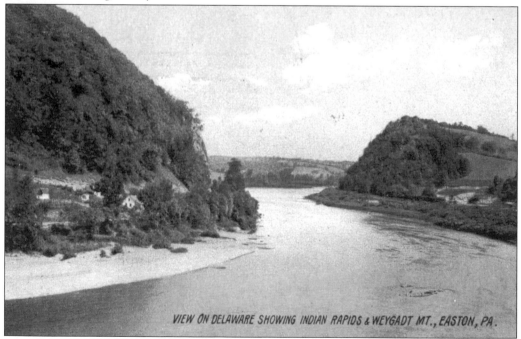

VIEW ON DELAWARE SHOWING INDIAN RAPIDS & WEYGADT MT., EASTON, PA.

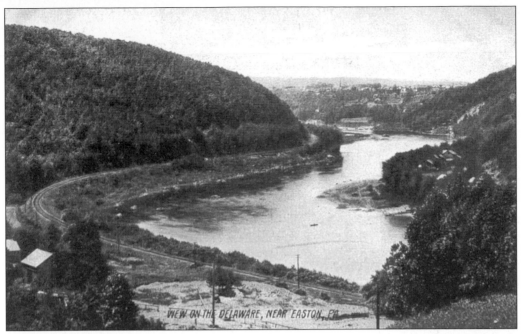

VIEW ON THE DELAWARE, NEAR EASTON, PA.

Looking through Weygadt Gap from the air, the heights of Easton, Pennsylvania, can be seen. On the New Jersey side, the Pennsylvania Railroad's Belvidere-Delaware division passes through the gap heading north to Belvidere and the connection with the Delaware, Lackawanna, and Western Railroad.

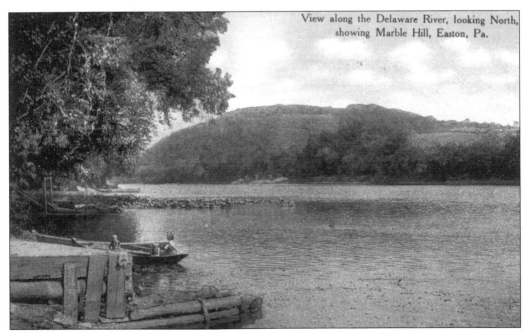

View along the Delaware River, looking North, showing Marble Hill, Easton, Pa.

This boat dock would have been a good place to fish while enjoying the view upstream to Marble Mountain.

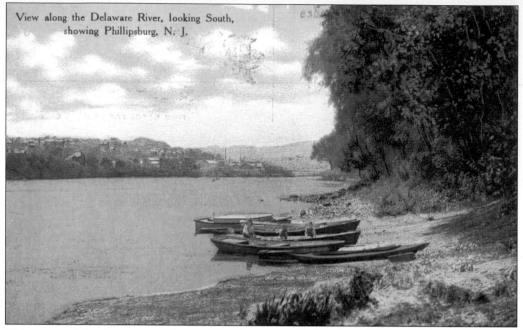

View along the Delaware River, looking South, showing Phillipsburg, N. J.

This postcard is the reverse view of the last one, this time it looks downstream from the Pennsylvania shore to Phillipsburg, New Jersey, a large town on the hills overlooking Easton. The tandem open-decked kayak is an attractive example of 19th-century canoes.

Looking up the Delaware River, Easton, Pa.

A quarter mile above the location in this postcard, the *Alfred Thomas* exploded on March 6, 1860. The 87-foot steamboat was constructed in South Easton, Pennsylvania, for a planned steamboat service between Belvidere, New Jersey, and Port Jervis, New York. Thirteen people were killed and 15 seriously injured when the boat suddenly exploded and sank. The boat was subsequently raised, rebuilt, and saw service on the Schuylkill River and during the Civil War.

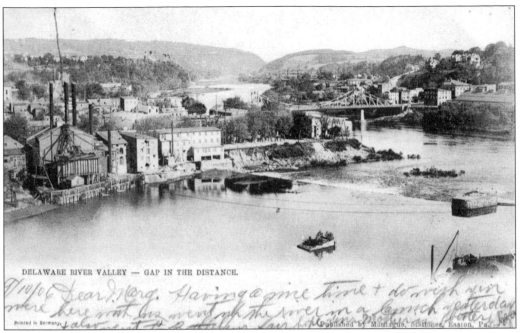

DELAWARE RIVER VALLEY — GAP IN THE DISTANCE.

9/10/06 Dear Marg. Having a fine time + do with us were here not long went up the river in a launch yesterday

Printed in Germany. Published by Montague, Stationer, Easton, Pa.

This view across the Lehigh and Delaware Rivers shows Easton, Pennsylvania (left), and Phillipsburg, New Jersey (right), on opposite sides of the Delaware. Weygadt Gap is seen in the north. The junction of the Lehigh and Delaware Rivers was known as the Forks of the Delaware. In the 1980s, a fish ladder was installed on the Lehigh's dam for shad migration.

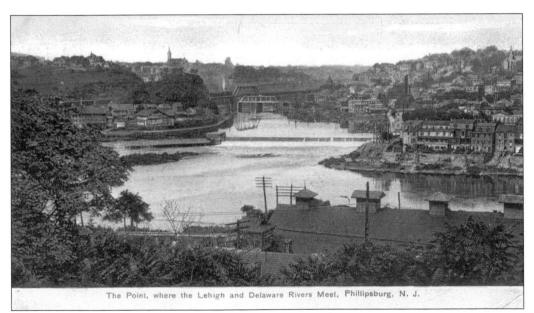

The Point, where the Lehigh and Delaware Rivers Meet, Phillipsburg, N. J.

In this postcard, Easton, Pennsylvania, is seen from Phillipsburg, New Jersey. The Lehigh Canal meets the Delaware division of the Pennsylvania Canal in the left of this scene, masked by the tree. The first shipment of coal down the Lehigh Canal is considered by some to be the beginning of the industrial revolution in America.

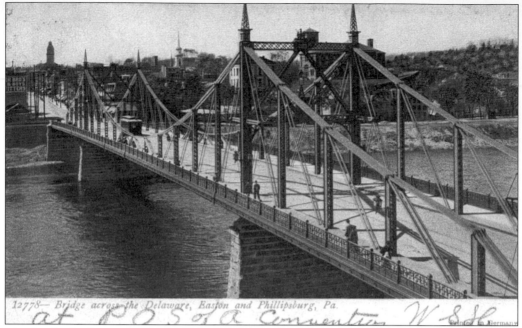

12778— Bridge across the Delaware, Easton and Phillipsburg, Pa.

The first bridge between Easton, Pennsylvania, and Phillipsburg, New Jersey, opened in 1806. It was the second covered bridge built in the United States. The Northampton Street Bridge, a unique suspension bridge design, shown here, replaced it in 1896 and still exists.

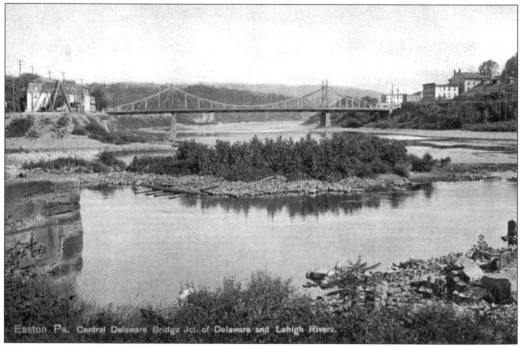

Easton, Pa. Central Delaware Bridge Jct. of Delaware and Lehigh Rivers.

This view of the Delaware River from the Lehigh River dam looks similar today. The little island in front of the dam is caused by the Lehigh River colliding with the larger Delaware River during times of high runoff. The sudden decrease in flow velocity causes the rocks and gravel to fall out, with larger stones followed by increasingly smaller ones.

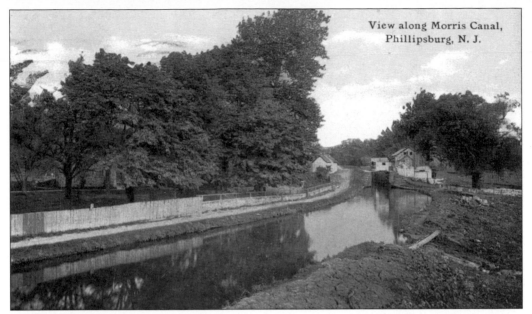

View along Morris Canal,
Phillipsburg, N. J.

The Easton-Phillipsburg area was the junction of three canals. Canal boats reached the Morris Canal in Phillipsburg by crossing the Delaware and entering a stone tunnel located under a railroad bridge, still visible today. The unique canal, with its inclined planes, opened across New Jersey in late 1831, running 90 miles to Newark. It was later extended to Jersey City. Several sections of the canal have been preserved.

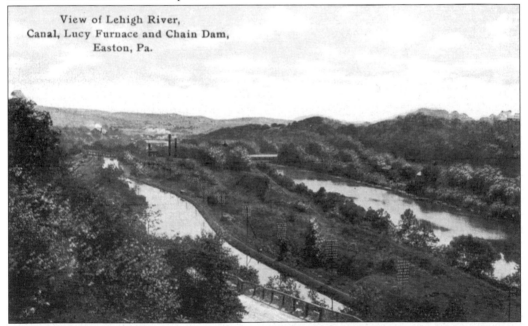

View of Lehigh River,
Canal, Lucy Furnace and Chain Dam,
Easton, Pa.

The significance of the Lehigh Canal to American history cannot be overstated. The coal hauled down the canal stimulated the industrial growth in the Allentown, Bethlehem, and Easton areas, in Philadelphia, and in the nation. At its peak, about 1.3 million tons of coal were hauled. The National Canal Museum in Easton has more information, and a boat pulled by two friendly mules on a restored section of the canal helps to recreate the past.

View on Easton Trolley.

Dear Brother, This is prettier than "Frog Pond" isn't it. Elsie.

In this view, the Delaware River sweeps to the right and heads downstream toward Raubsville, Pennsylvania. The stone carbarn that formerly housed the trolleys of the Philadelphia and Easton Railway is located there. The tracks of the trolley line with its poles are in the foreground.

Del. River.
Canal.

This scene looks upstream at Whippoorwill Island, on the outside of the bend. The Delaware division of the Pennsylvania Canal, in the foreground, was completed from Easton to Bristol in 1833. Its main purpose was to extend the Lehigh Canal to tidewater. Today, the canal is preserved as Delaware Canal State Park and the dirt road is Pennsylvania Route 611.

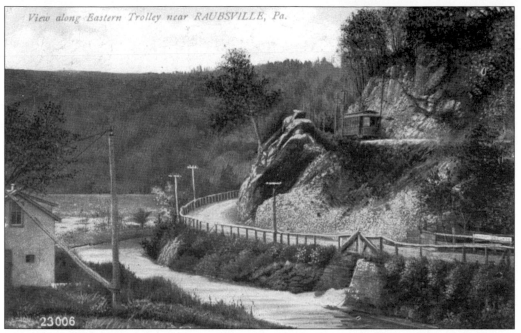

View along Eastern Trolley near RAUBSVILLE, Pa.

23006

The Philadelphia and Easton Railway was a country trolley line that connected Doylestown and Easton, Pennsylvania, from 1904 to 1926. The highly scenic line paralleled the Delaware River for one third of its route and was one of the participants in the Delaware Valley Route service between Philadelphia and the Delaware Water Gap. Portions of the route are visible today.

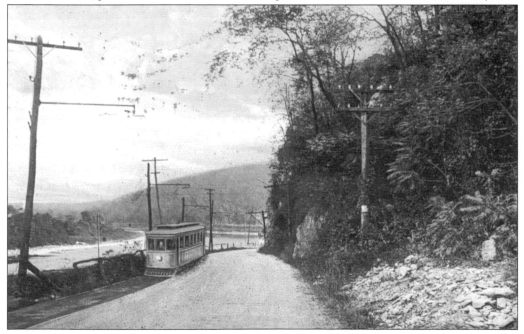

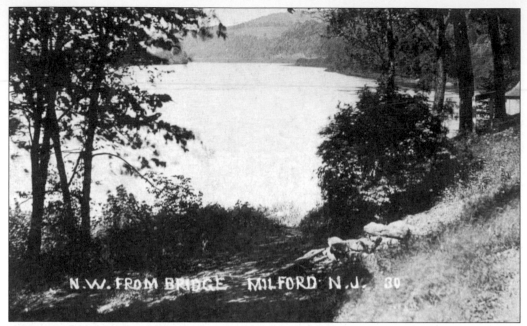

N.W. FROM BRIDGE MILFORD N.J. 30

Milford, New Jersey, is about 35 miles upstream of Trenton, New Jersey. The name, Milford, is a reference to the number of gristmills in the area. Upstream from this site is one of the few one-lane roads left in New Jersey. Cliffs and railroad tracks running along the river squeeze the road. Native prickly pear cacti can be found on the cliff's ledges.

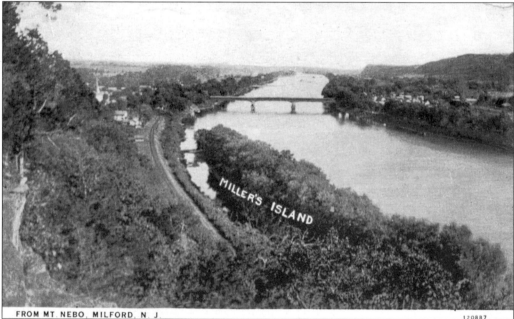

MILLER'S ISLAND

FROM MT. NEBO, MILFORD, N. J. 120887

This view is from the top of the Milford cliffs, looking downstream. Milford is on the left and Upper Black Eddy, Pennsylvania, is on the right. An old, wooden covered bridge connects the towns. When the 1903 flood heavily damaged this bridge, repairs were made using timbers from the Riegelsville covered bridge that had been swept down to Milford. Later, a steel one completely replaced the bridge.

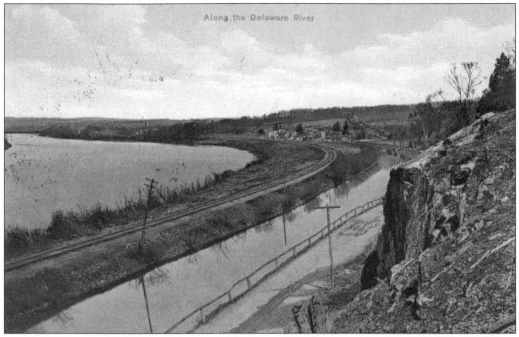

This upstream view of the Delaware shows Brookville and Stockton, New Jersey. The Stockton covered bridge crosses the Delaware in the upper part of the postcard. This bridge burned after being struck by lightning in the 1920s. The canal is the Delaware and Raritan Canal's feeder that delivered water from the Delaware to the main canal in Trenton, New Jersey. Canal boats used it too.

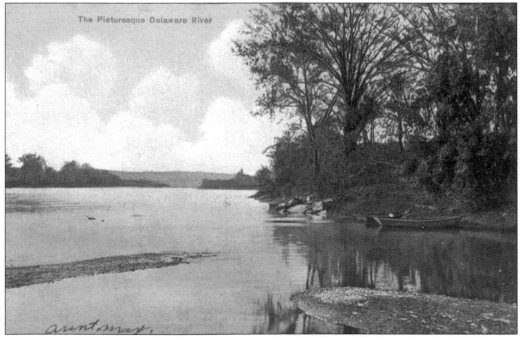

This postcard view, downstream from Stockton, New Jersey, shows the tail waters of a large pool backed up behind the Lambertville–New Hope wing dams. The U.S. Route 202 Bridge would be upstream in this view today.

SCENE AROUND NEW HOPE. PA.

These two scenes are described as being near New Hope, Pennsylvania. The first looks upstream and the second downstream, although from different locations. New Hope was originally a canal town, but later the Reading Railroad built a branch to it. Today, New Hope has dozens of antique and specialty stores, restaurants, a playhouse, and other enterprises catering to tourists.

The picturesque Delaware River at Lathrop's Grove, showing the Old Sycamore Tree, near New Hope, Penna. (Coryell's Ferry of the Revolution)

Old Bridge, Lambertville, N. J.

The Lambertville-New Hope covered bridge was destroyed in the 1903 flood and replaced by the one existing today. This view of the older bridge looks across to New Hope, Pennsylvania, from Lambertville, New Jersey. Postcard manufacturers seldom published winter views of Delaware valley scenes.

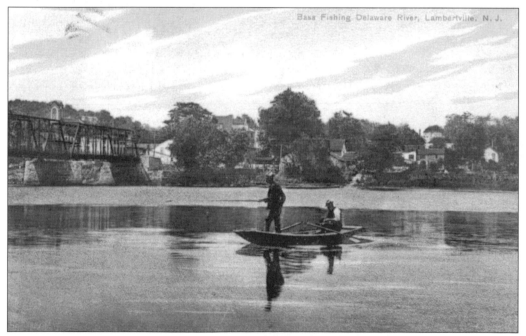

Bass Fishing Delaware River, Lambertville, N. J.

Fishing for smallmouth bass still occurs in the Lambertville–New Hope pool. These fellows are upstream of the 1904 steel bridge that replaced the covered one. New Hope, Pennsylvania, is in the background.

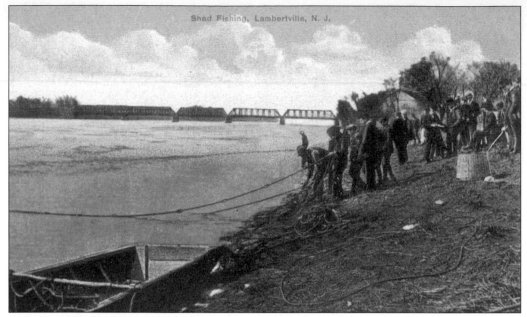

The Lambertville Shad Festival, held each spring, celebrates the return of substantial American shad migrations to the Delaware River. From *c.* 1900 until the mid-1980s, shad fishing was hit or miss because the shad had trouble passing through the pollution created in the river off of Philadelphia, Pennsylvania, and Camden, New Jersey. The cleanup of the tidal Delaware is a premier water-pollution success story.

DELAWARE RIVER

In good years and bad, the members of the Lewis family fished for shad off of this island, now named Lewis Island. The family has the last commercial license, issued in 1888, allowing the netting of shad on the Delaware River. The family fishery is the star of the Lambertville Shad Festival and a source of information for government and academic researchers.

View of Delaware River, Through the Trees, Lambertville, N. J.

This view, taken south of today's Lambertville wastewater treatment plant, looks to New Hope, Pennsylvania. Near here was a lock that allowed canal boats from New Hope to enter the Delaware and Raritan Canal. A cable was used to bring the boat across the river while the mules crossed by bridge. Canal boats heading to New Jersey and New York took advantage of this crossing.

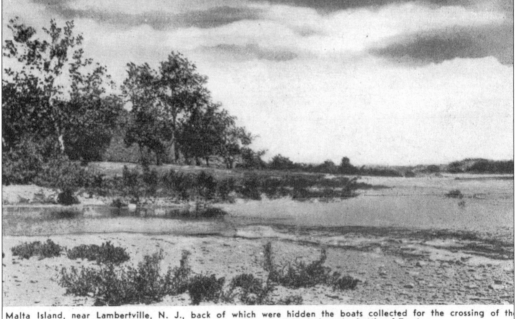

Malta Island, near Lambertville, N. J., back of which were hidden the boats collected for the crossing of the Delaware by the American Army, Dec. 25, 1776, before the battle of Trenton.

Legend has it that before the famous Delaware River crossing, General Washington crossed over to New Jersey to see for himself if the British scouts could see his boats. The boats—Durham boats, coal arks, and whatever else could be found—were hidden behind various Delaware River islands until needed. Malta was one such island.

91

Wells Falls, the rapids below the Lambertville-New Hope wing dams, are some of the worst rapids on the Delaware. They are seen here under two different flow conditions. Over the years, a variety of watercraft have met their doom here, including lumber rafts, canoes, an Adirondack guide boat in 1876, and, as recently as 2000, a small tour boat from New Hope. The two wing dams, one from each state, date from canals built in the 1830s. The dams were rebuilt in the 1960s. Wing dams are partial dams used to raise the water for mills, canals, and other purposes.

Welles Falls, Delaware River at Low Water.

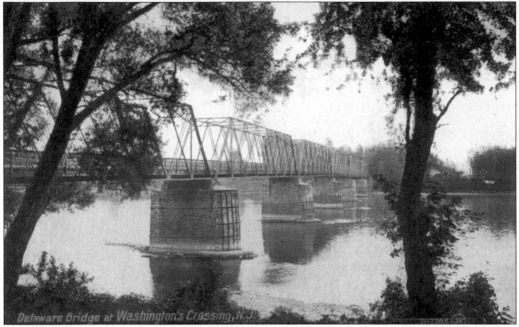

Delaware Bridge at Washington's Crossing, N.J.

The Washington Crossing Bridge is the third bridge located at the site of Washington's historical crossing of the Delaware River. This bridge was built in 1904 and is 877 feet long. Taylorsville is located on the Pennsylvania side of the river.

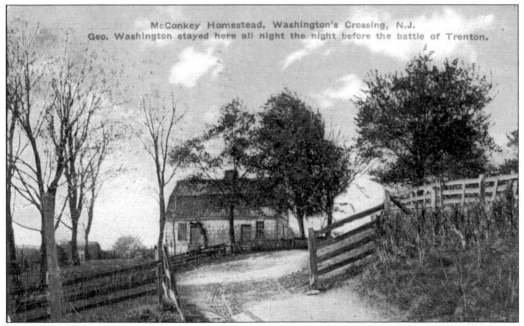

McConkey Homestead, Washington's Crossing, N.J.
Geo. Washington stayed here all night the night before the battle of Trenton.

This old building is preserved at the Washington Crossing State Park in New Jersey. The old road that appears on the right of the building is no longer in service, but was used by Washington's army in 1776. State parks honoring the famous Delaware crossing are located on both sides of the river. The 2001 annual re-enactment of the crossing on Christmas Day attracted 20,000 people.

93

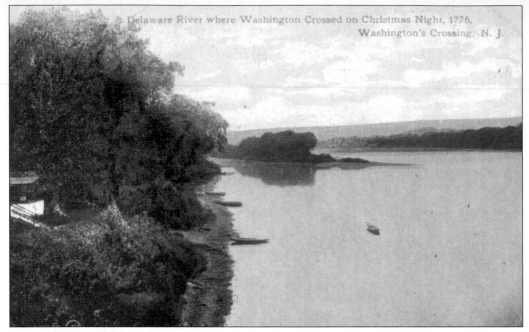

In one of the boldest military movements in American history, George Washington and his army made a nighttime crossing of the Delaware on Christmas Eve 1776. The army landed on the New Jersey side of the river, split into two units, and subsequently defeated the Hessian mercenaries and British soldiers in the Battle of Trenton. The shoreline seen in this view (above) is the old McConkey Ferry landing where some of the boats were launched. The second scene (below) shows the monument located on the Pennsylvania side of the river.

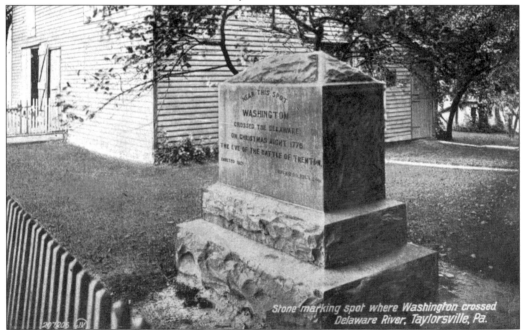

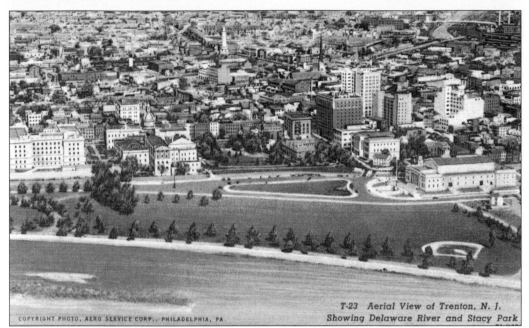

T-23 Aerial View of Trenton, N. J.
Showing Delaware River and Stacy Park

This postcard shows Trenton, New Jersey, the state capital. The Delaware River is almost in the backyard of the capitol building. The tall tower that appears in the top of the scene is the Trenton Battle Monument, marking where Washington's victory took place. The two canals are the Delaware and Raritan Canal and the Trenton Water Power Canal, the latter is behind the capitol.

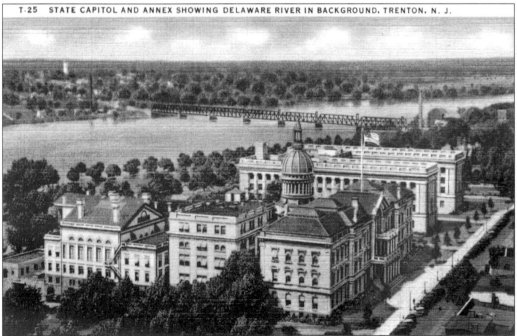

T-25 STATE CAPITOL AND ANNEX SHOWING DELAWARE RIVER IN BACKGROUND, TRENTON, N. J.

The relationship of the New Jersey state capital to the Delaware River is shown here. The Calhoun Street Bridge is seen crossing the river to Morrisville, Pennsylvania. The hills of Bucks County are on the horizon. Just downstream and out of view is the head of tide, below a rocky rapid known as Trenton Falls.

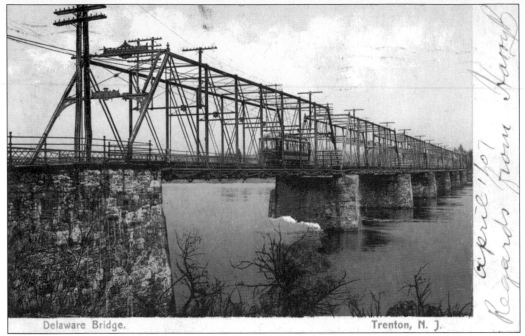

Delaware Bridge. Trenton, N. J.

The Calhoun Street Bridge opened in 1861 as a covered bridge. After fire destroyed it in 1884, the bridge shown in this postcard was built. At one time, the developers of various Bucks County trolley lines owned the bridge. Trolleys using the bridge ran to Morrisville, Yardley, Newtown, and New Hope, Pennsylvania, and to Lambertville, New Jersey.

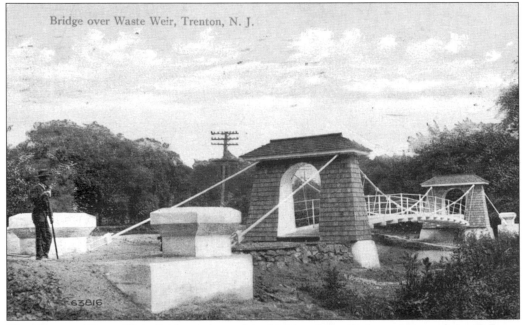

Bridge over Waste Weir, Trenton, N. J.

The Trenton Waste Weir Bridge is located in Mahlon Stacy Park, upstream of the Calhoun Street Bridge. It can be seen from Route 29. The waste weir is for spilling excess water from the Delaware and Raritan Canal into the Delaware River. The bridge was donated to the city by the Roebling family of suspension bridge fame.

Four

TRENTON, NEW JERSEY, TO THE ATLANTIC OCEAN

At Trenton, New Jersey, the Delaware River becomes tidal. Although the river from Trenton to the Atlantic Ocean is affected by twice-daily tides, it remains largely a freshwater river until below Wilmington, Delaware. The freshwater reach of the tidal river is often called the Delaware Estuary, but this is a misnomer. From a scientific perspective, the Delaware's estuary is actually Delaware Bay.

The tidal Delaware is a broad river that widens on its way to the ocean. After the Civil War, it became necessary to dredge the river due to increased ship sizes. In Philadelphia, the Delaware River's largest tributary, the Schuylkill, joins the river.

The Delaware Estuary became, by 1900, one of the world's largest concentrations of heavy industry. Steel making, oil refining, papermaking, shipbuilding, and manufacturing plants of all kinds lined the shores of the river. Large transportation and shipping facilities, power plants, and rapidly increasing populations supported this development. As a result, the Delaware Estuary became grossly polluted.

In spite of the industrialization, a great deal of recreation occurred on the tidal river. Sailing was especially popular. The Delaware Bay was largely unaffected by industry. People flocked to its beaches, and its marshes attracted hunters from the cities. Fishing and oystering were large industries. Today, deindustrialization and the cleanup of water pollution are transforming the banks of the river, creating widespread interest in the tidal river's natural and recreational values. The Delaware Estuary Program, established in 1988, is one of 28 national estuary programs that support these values.

DELAWARE RIVER BELOW OLD P.R.R. BRIDGE
18875 Trenton, N.J.

The Camden and Amboy Railroad, one of the first railroads in the United States, was built in 1834 between Perth Amboy and Camden, New Jersey. The line passed six miles south of Trenton. In 1863, the Pennsylvania Railroad absorbed it and built a more efficient route, crossing the Delaware River at Trenton. The line was completed to Newark, New Jersey, in 1871. This double-tracked iron bridge replaced the original railroad bridge in 1875.

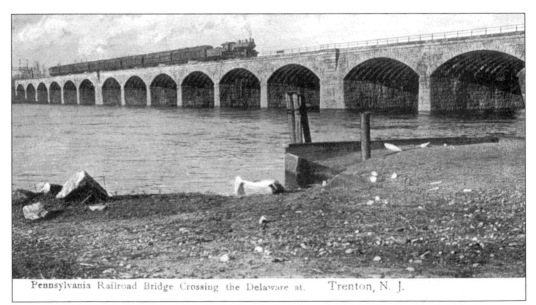

Pennsylvania Railroad Bridge Crossing the Delaware at. Trenton, N. J.

This stone arch bridge—still used by trains arriving and leaving Trenton, New Jersey—replaced the Pennsylvania Railroad's iron bridge in 1903. AMTRAK and other trains running on the main line between New York and Washington use the bridge today. Steam locomotives pulling passenger trains, like the one shown in the postcard, disappeared in 1933 when the line was electrified.

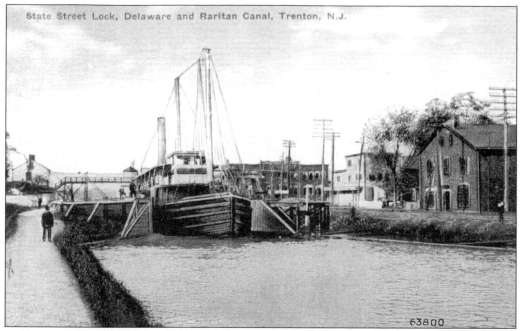

63800

This postcard shows a ship passing through the State Street Lock on the Delaware and Raritan Canal in Trenton, New Jersey. Beginning in 1834, the canal, one of the more successful, ran between Bordentown, New Jersey, on the Delaware and New Brunswick, New Jersey, on the Raritan for 100 years. Most of this canal has been preserved as a park and water supply, but the portion in this postcard no longer exists.

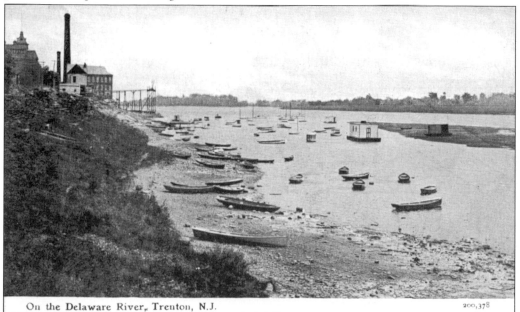

On the Delaware River, Trenton, N.J. 200,378

This unused postcard shows an array of boats moored along the shore at Trenton, New Jersey, including small sailboats, canoes, and houseboats. The tide is obviously out and everybody must be at work. A dock for larger boats and smokestacks from one of Trenton's many industries can be seen.

99

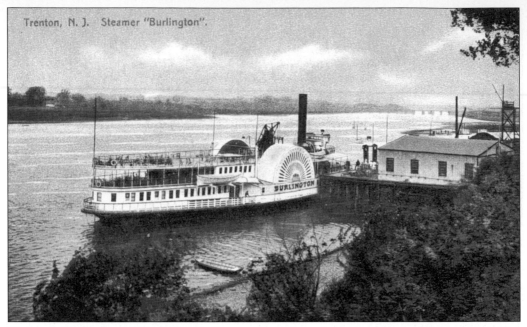

Harlan & Hollingsworth built the *Burlington,* shown here docked at Trenton, New Jersey. The 1856 steamboat was originally the *John A. Warner.* It carried passengers and freight between Philadelphia and Trenton until it was destroyed on a rock in 1911. Interestingly, the first successful steamboat in the world, invented by John Fitch, ran on the Delaware River in 1787. Also visible in this postcard is the Pennsylvania Railroad Bridge crossing the river in the distance.

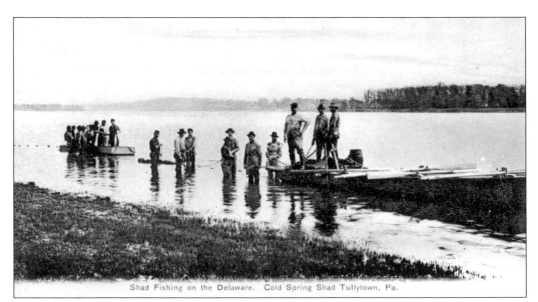

Shad Fishing on the Delaware. Cold Spring Shad Tullytown, Pa.

Tullytown in Bucks County, Pennsylvania, was the site of one of the oldest shad fisheries on the Delaware. Located where Common Creek empties into the river, the Burton family owned the fishery for two centuries. American shad migrate up the Delaware River each spring to spawn, thus the reference to "Cold Spring Shad." The smaller males usually run the river first, followed by the females.

100

Florence Heights, N. J., looking
east along Delaware River.

This postcard shows an upstream view of the shoreline of Florence, New Jersey, *c.* 1900, "a community with character at the bend of the river." The town was organized in 1849 by a group of New York financiers and maintained a mix of tourism, agriculture, and industry throughout the 19th and early 20th centuries. In 1872, a Philadelphia doctor opened a "Hygeian Home and Hygero Therapeutic College" in Florence to take advantage of the spring waters in the area.

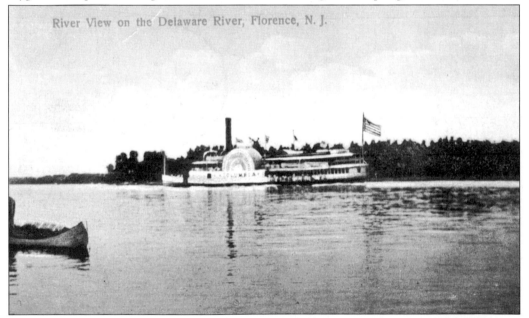

River View on the Delaware River, Florence, N. J.

This postcard shows the steamboat *Columbia* heading downstream from the dock in Florence, New Jersey. The ferry would stop here on its way between Trenton and Philadelphia. The sender of this 1915 postcard wrote, "This is the pretty Delaware. I see this boat – the 'Columbia' go up and down the river twice a day. Some day, I will take it Phil. To see Aunt Margaret." Today, a large sanitary landfill looms over this scene on the Pennsylvania side of the river.

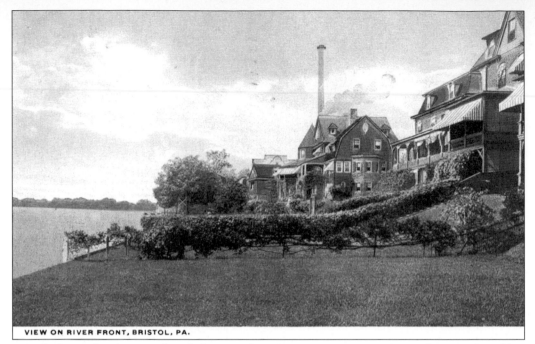

VIEW ON RIVER FRONT, BRISTOL, PA.

Bristol, Pennsylvania, was founded more than 300 years ago in 1681, making it the oldest borough in the state. Bucks County, the location of Bristol, was named after William Penn's English estate, Buckinghamshire. Pennsbury Manor, his North American estate, is located several miles upstream from Bristol. The card above, postmarked in 1919, shows the Bristol riverfront. Remarkably, the riverfront still looks much like this image today. The postcard below is a view of downtown Bristol. The two views can be oriented to each other by the tall smokestack seen in both scenes.

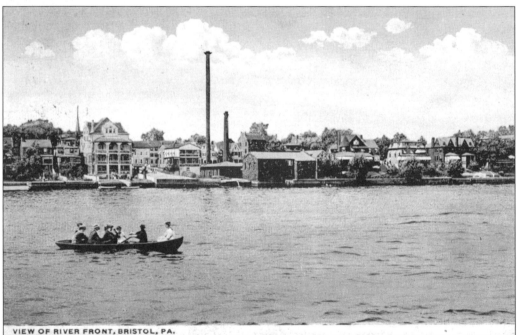

VIEW OF RIVER FRONT, BRISTOL, PA.

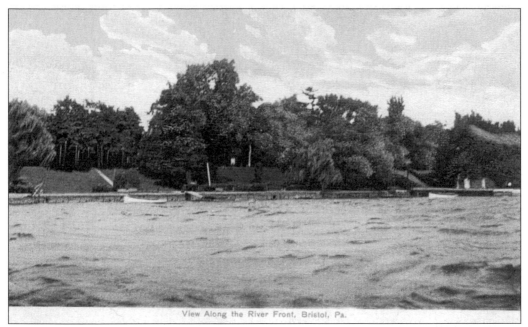

View Along the River Front, Bristol, Pa.

This postcard shows a view of the boat docks along the Bristol waterfront. It looks much the same today. The message on this postcard from June 1910 is humorous, "Friend Charles, I had to wait 45 minutes for the Newtown trolley, so I hunted some postals, it is a fine cool morning, Your Friend, Ida."

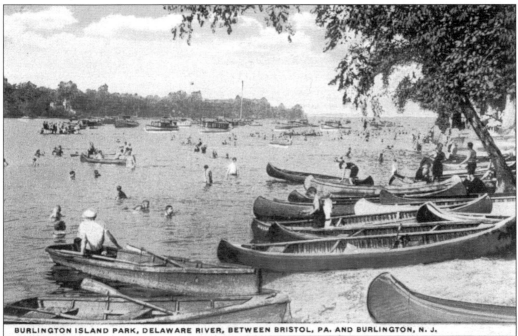

BURLINGTON ISLAND PARK, DELAWARE RIVER, BETWEEN BRISTOL, PA. AND BURLINGTON, N. J.

Burlington Island is a 400-acre island in the Delaware River off the coast of Burlington, New Jersey. It gained popularity in the early 1900s as a picnic grove. At first accessible only by boat, soon a footbridge connected it to New Jersey and ferries ran to Pennsylvania. The park featured a roller coaster, carousel, Ferris wheel, and more. A fire gutted the park in 1928 and it was never rebuilt.

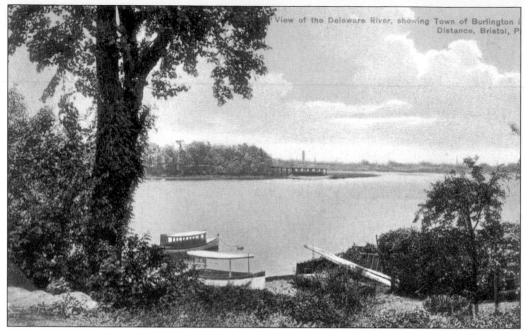

Burlington Island and the town of Burlington, New Jersey, (behind and to the right of the island) are viewed from Bristol, Pennsylvania. The boats in the foreground are quite lovely. The riverfront still looks much like this today.

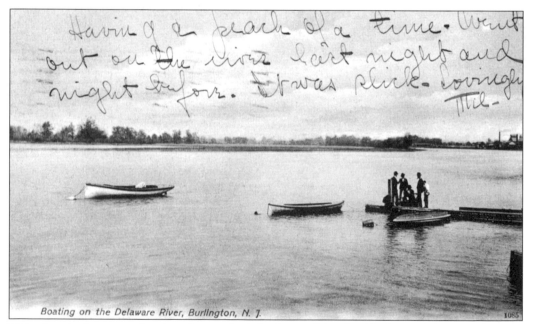

Boating on the Delaware River, Burlington, N. J. 1085

This view looks across the river from a dock in front of the Oneida Boat Club in Burlington, New Jersey. The shadow of the downstream end of Burlington Island is seen on the right. The factory with its smokestack is in Bristol, Pennsylvania. The 1909 message reads, "Having a peach of a time. Went out on the river last night and night before. It was slick."

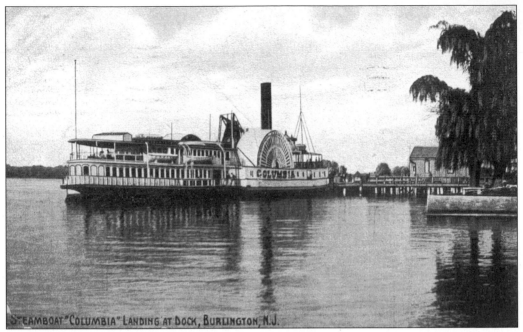

The *Columbia* is shown docking in Burlington, New Jersey, about halfway between its run from Trenton to Philadelphia. Harlan & Hollingsworth built the *Columbia* in 1876 for the Delaware River Steamboat Company.

This view looks upstream at the Burlington wharf area, with Burlington Island and Pennsylvania in the distance. A steamboat has just left the dock. Steamboats plied the Delaware until modern highways and river bridges were built in the 1920s. The Pennsylvania Railroad served both sides of the river and provided ferry service in Philadelphia, but steamboat service was more direct.

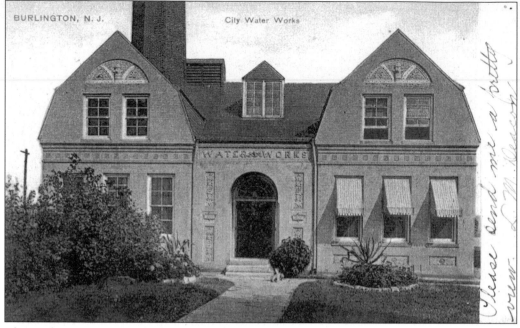

The Burlington Post Card Company published this card showing the Burlington, New Jersey, city water works building. The structure was built in 1897, although the water system was much older. The brick stack coming out of the roof was for the steam-driven pumps. This building is located along the riverfront next to the Oneida Boat Club and a church. It still stands, although it is empty and for sale. The shrubs in the lower left of the image disguise a cemetery.

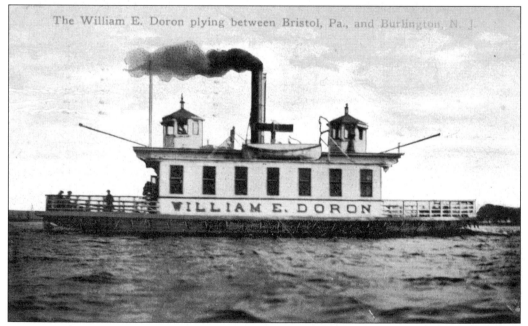

The steamer *William E. Doron* was one of the ferryboats that carried park visitors between Bristol and Burlington Island Park, New Jersey. The covered dock in Bristol is still a nice place to lounge about and enjoy the river.

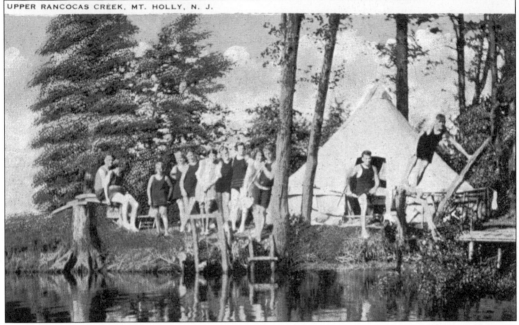

The coastal plain of New Jersey abuts the tidal Delaware and many of its tributaries are partially tidal. Rancocas Creek is one example. It flows northwest out of the famous New Jersey Pine Barrens and meanders many miles to tidewater, in this case at Mount Holly, nine miles from the Delaware. These young people with their tent and swimming hole appear to be enjoying life.

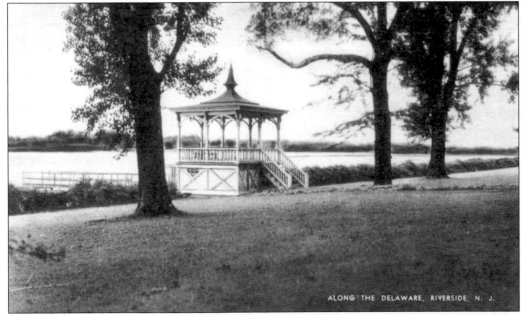

ALONG THE DELAWARE, RIVERSIDE, N. J.

Founded in 1851, the tiny town of Riverside, New Jersey, was a summer resort town. The town's main industry was the Philadelphia Watch Case Company. At the company's peak, its 1,000 employees could make 6,000 watchcases per day. Although the company closed in 1972, the building still anchors downtown Riverside. This postcard shows a peaceful gazebo along the shore of the Delaware in Riverside.

107

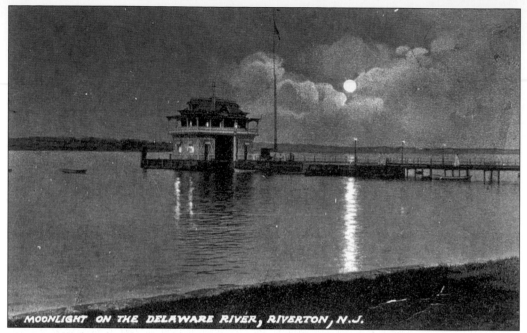

MOONLIGHT ON THE DELAWARE RIVER, RIVERTON, N.J.

This moonlight view depicts the Riverton Yacht Club on the water in Riverton, New Jersey. Founded in 1865, this is the oldest yacht club on the Delaware and the ninth oldest club in the nation. This clubhouse, built in 1880, can still be seen by passing boats or from the Tacony-Palmyra Bridge, just south of the clubhouse.

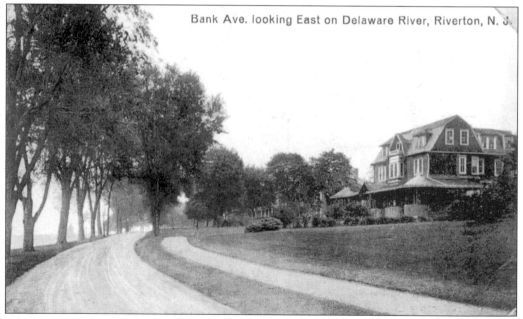

Bank Ave. looking East on Delaware River, Riverton, N. J.

Riverton, New Jersey, was founded in 1851 by 10 merchants from Philadelphia looking to build summer homes along the Delaware. This postcard looks upriver at the town, which became one of the first fully planned residential subdivisions in America. A restaurant menu in a foreign language, presumably German, is printed on the back of this card on top of the postal information, suggesting that the card never left Germany, where it was printed.

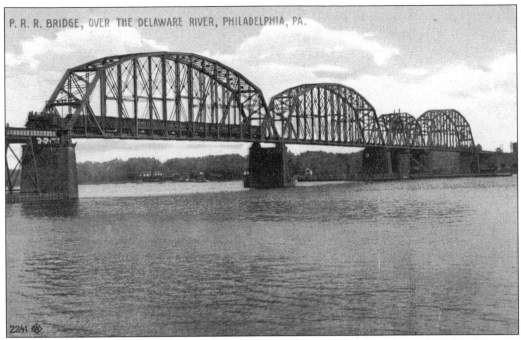

The Pennsylvania Railroad's Delair Bridge was built in 1896. The bridge was built to create an all-rail route from Philadelphia to the New Jersey shore. The message on the back reads, "Dear western friend, Here is a fine bridge over the Delaware, the only one between the City of Trenton and the ocean." It would keep that distinction until the Ben Franklin Bridge opened in 1926.

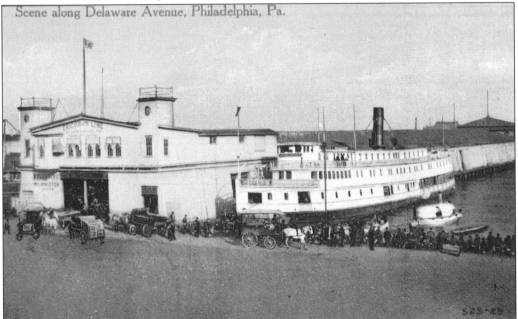

The Philadelphia waterfront was home to many shipping firms. This image shows the wharf of the Ericsson Line that ran a fleet of boats between Philadelphia and Baltimore. Note the wagons unloading their cargo onto the steamboat, as well as the long line of passengers waiting to board the ship.

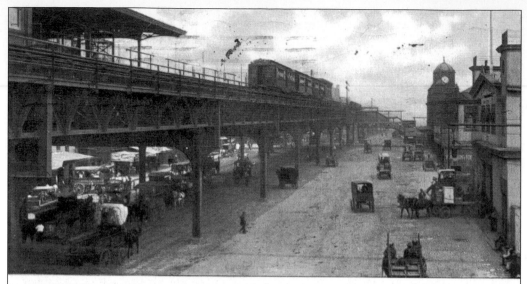

Philadelphia—Terminus of Subway and Elevated. This structure, cutting its way through the heart of the City at Market St., finds a terminus at Delaware Ave., on the river front To the right are the Stations of the Pennsylvania and Reading Railroads from which travellers to Atlantic City and other Jersey Coast resorts depart. On Saturday afternoons as many as 200,000 persons make exit for the seashore from this point The many freight shipping depots of the steamship lines make Delaware Ave. a busy thorofare at all times

Philadelphia's elevated railroad brought rapid urban transportation to the shores of the Delaware River. According to the above postcard, "This structure, cutting its way through the heart of the City at Market Street, finds a terminus at Delaware Ave. on the waterfront. To the right are the stations of the Pennsylvania and Reading Railroads from which travelers to Atlantic City and other Jersey Coast resorts depart. On Saturday afternoons as many as 200,000 persons make exit for the seashore from this point. The many freight shipping depots of the steamship lines make Delaware Ave. a busy thorofare at all times." Today's Delaware Avenue, renamed Columbus Boulevard, looks vastly different than it appears here. It now contains parks, museums, restaurants, and nightclubs.

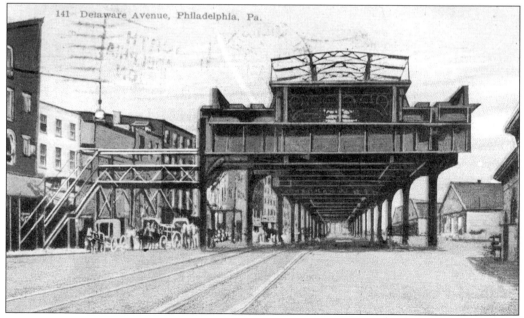

141 Delaware Avenue, Philadelphia, Pa.

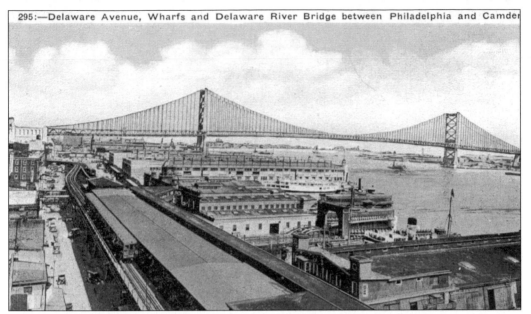

295:—Delaware Avenue, Wharfs and Delaware River Bridge between Philadelphia and Camden

This postcard claims to show the Delaware River Bridge between Philadelphia, Pennsylvania, and Camden, New Jersey. The bridge is actually only a drawing of the proposed Delaware River Bridge, now known as the Ben Franklin Bridge, which was set to open in 1926. The bridge took four years to build at a cost of more than $37 million. The Philadelphia waterfront along Delaware Avenue is also shown.

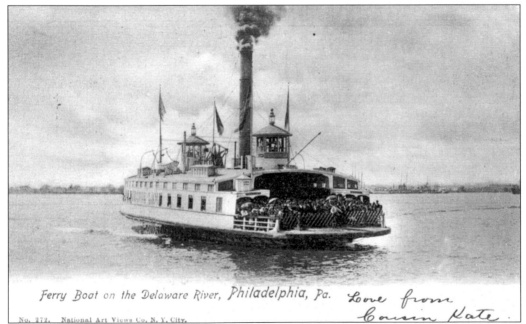

Ferry Boat on the Delaware River, Philadelphia, Pa. Love from Cousin Kate.

No. 272. National Art Views Co. N. Y. City.

In the late 1800s, a narrow island was removed from the river between Philadelphia, Pennsylvania, and Camden, New Jersey, allowing for uninterrupted ferry service. People would wait in line for hours for the 15-minute ferry trip across the river, which was often not very pleasant. Industries along the river had polluted the water to the point that dockworkers often became ill from the smell.

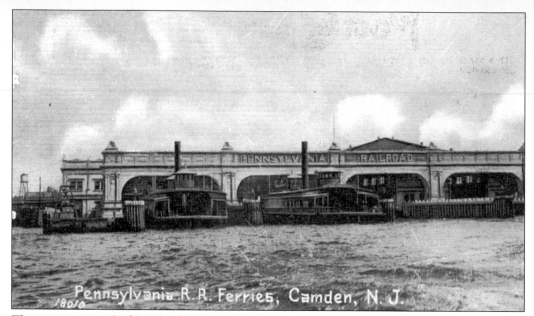

Pennsylvania R.R. Ferries, Camden, N.J.
/80/0

These two postcards, from the first decade of the 20th century, show the Pennsylvania Railroad's ferryboat terminals on the Camden, New Jersey, and Philadelphia, Pennsylvania, sides of the Delaware. Before the construction of bridges across the river, train passengers traveling to Atlantic City or other spots on the New Jersey coast would disembark in Philadelphia and take the ferry to Camden. The design of the interiors of the Pennsylvania Railroad ferryboats have been attributed to the firm of noted architect Frank Furness.

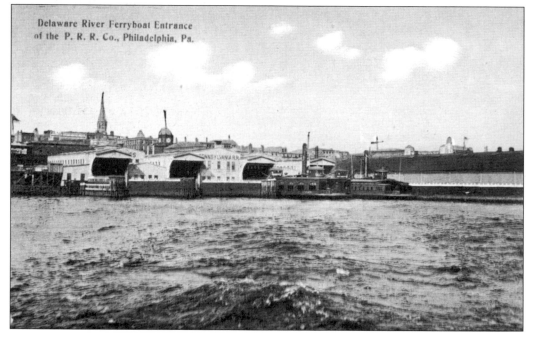

Delaware River Ferryboat Entrance
of the P. R. R. Co., Philadelphia, Pa.

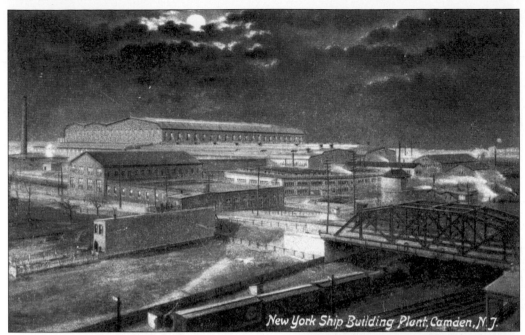

New York Ship Building Plant, Camden, N.J.

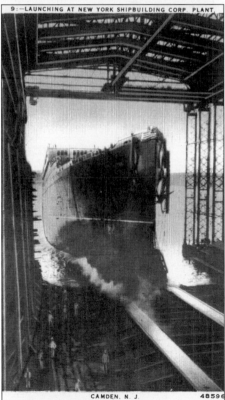

9:—LAUNCHING AT NEW YORK SHIPBUILDING CORP. PLANT

CAMDEN, N. J. 48596

The postcard above shows a night view of the New York Shipbuilding Plant in Camden, New Jersey. Henry G. Morse originally wanted to base his shipbuilding company out of Staten Island, New York. After naming the company, he decided that Camden would be a more lucrative location. Between 1900 and 1967, the company built many cargo and battle ships. Although much of the yard has been destroyed, the area now contains warehouses and other industrial buildings. The piers still serve some general cargo ships. The launching of a new ship, as shown on the right, was a major source of pride for shipbuilders and their workers. In this view, a ship that will likely travel all over the world to many ports, first tests the waters of the Delaware River.

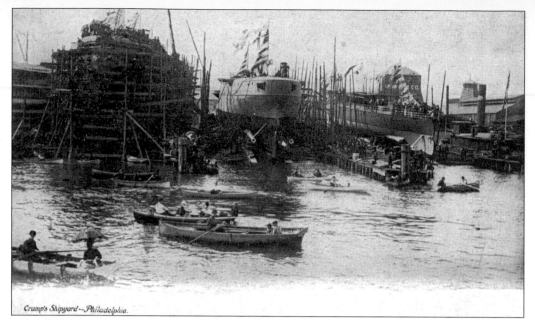

Cramp's Shipyard--Philadelphia.

By the end of the 19th century, the Delaware River was called the American Clyde, after the Scottish shipbuilding industry on the Clyde River. The combination of wooden shipbuilding, engine-building, heavy-metal industries, and a skilled labor force, made Philadelphia, Pennsylvania, and Camden, New Jersey, leaders in iron and steel shipbuilding in the 20th century. The shipbuilding industry along the Delaware has largely died out, although there have been attempts to attract companies to the Philadelphia Navy Yard. These two postcards depict the Philadelphia shipyard of William Cramp and Sons Ship and Engine Building Company, more commonly known as Cramps'. Both images appear to be taken around the same time, if not the same day. In the close-up, note the hundreds of workers on the scaffolding of the ship on the left and along the shore.

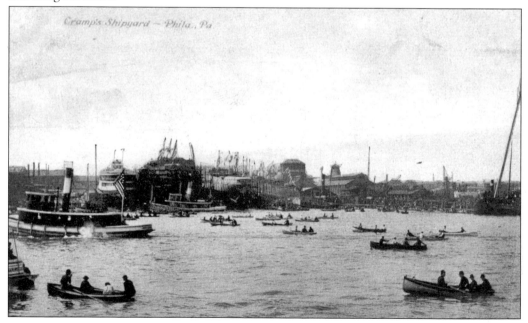

Cramp's Shipyard – Phila., Pa.

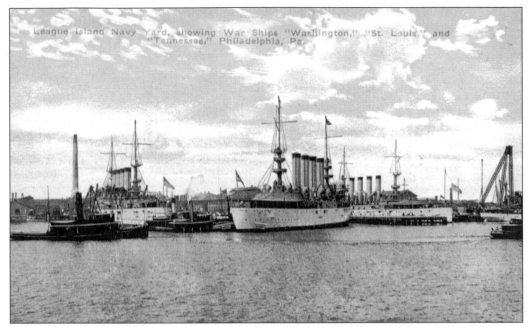

This postcard, copyrighted 1906, is a pre–World War I view of the Philadelphia Navy Yard on League Island. The ship in the center of the image is the *St. Louis,* built in Philadelphia and commissioned in August 1906. The ship served in the Pacific Fleet until 1917, when it transported American troops in the Atlantic. Decommissioned in 1922, the *St. Louis* was sold for scrap in 1930. The other ships are the *Washington* and *Tennessee.*

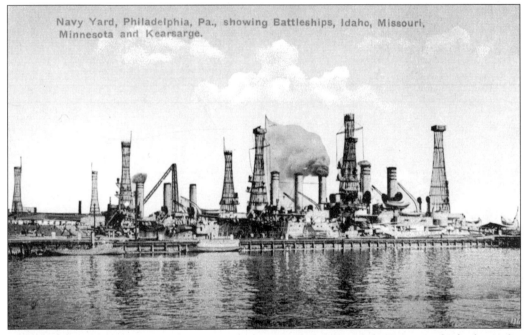

This card shows the battleships *Idaho, Missouri, Minnesota,* and *Kearsarge* docked at the Philadelphia Navy Yard. Taken during the first half of 1919, it shows the cage masts, a distinguishing characteristic of battleships of the World War I era.

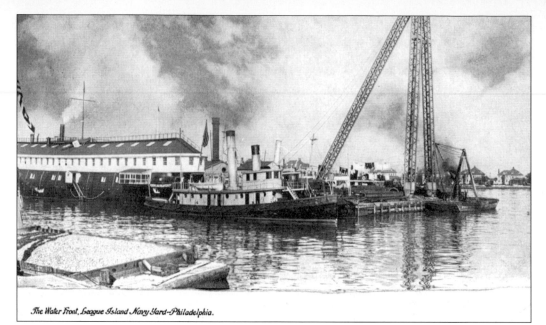

The Water Front, League Island Navy Yard–Philadelphia.

Although the Philadelphia Navy Yard closed in 1996, its history dates back almost to the founding of the U.S. Navy. Relocated to League Island in 1876, the yard was a hub for the shipbuilding industry along the river, making Philadelphia one of the most productive shipbuilding areas throughout World War I and World War II. This postcard shows the League Island Navy Yard *c.* 1900. Note the clothesline with laundry in the center.

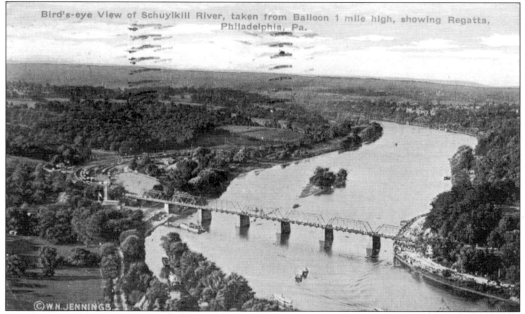

The 125-mile-long Schuylkill River is the Delaware's largest tributary. This bucolic view, looking upstream, is actually in Philadelphia, near the river's confluence with the Delaware. Several of the first recreational canoe trips down the Delaware were to the 1876 Centennial Exposition held in Fairmount Park, seen here on both sides of the river. The park is the largest urban park in the world.

Gloucester City, N.J. - Gloucester Ferry.

The first ferry between Gloucester City, New Jersey, and Philadelphia began in the late 17th century. By the late 19th century, a transportation network of trolleys, the Gloucester turnpike (a toll road), and the Gloucester ferry carried farm products, passengers, and industrial goods between the two sides of the Delaware. This postcard shows the ferry terminal in Gloucester City in the late 19th century. Note the elaborate cupola and the horse-drawn carriages.

Looking north from wharf, Billingsport, New Jersey.

The town of Billingsport was established in 1677 by Edward Billings, an associate of William Penn. Battles of the Revolutionary War and the War of 1812 occurred here. The town was home to shad fishing during most of the 19th century, until pollution ended the industry. At the time of this *c.* 1900 card, Billingsport was a small resort town for Philadelphia industrialists.

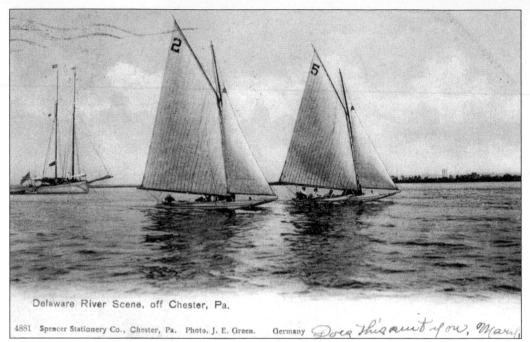

Delaware River Scene, off Chester, Pa.

4881 Spencer Stationery Co., Chester, Pa. Photo. J. E. Green. Germany *Does this suit you, Mary*

This image, postmarked 1907, shows sailboats racing on the Delaware off Chester, Pennsylvania. The scene is reminiscent of the 1874 painting, *Sailboats Racing on the Delaware,* by Philadelphia artist Thomas Eakins.

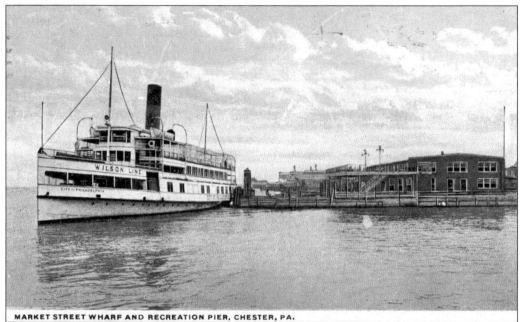

MARKET STREET WHARF AND RECREATION PIER, CHESTER, PA.

Founded in 1642, Chester is the oldest city in Pennsylvania. At the beginning of the 20th century, the city went through a boom period of industrial and population growth. Between 1910 and the time that this postcard was mailed in 1920, the city's population nearly doubled to 58,000. The steamer *City of Philadelphia* is shown here, part of the Wilmington Steamboat Company fleet that shuttled goods and people between Chester and Philadelphia.

118

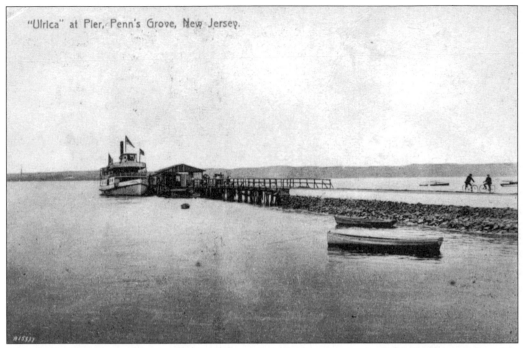

The *Ulrica* is docked at the landing in Penns Grove, New Jersey, in 1915. Ulrica is a Swedish name, possibly reflecting the heritage of Wilmington, Delaware.

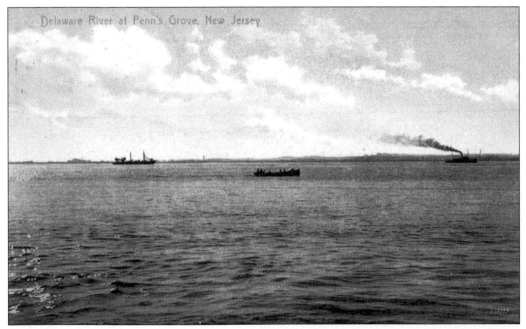

This postcard and the previous one capture the open expanse of the Delaware River below Pennsylvania. The view is from the shores of Penns Grove, New Jersey, looking toward Wilmington, Delaware. Note the three different types of watercraft: a steamer (possibly a tug), a commercial trawler, and a small motor launch. Today's Delaware Memorial Bridge crosses the river downstream of here.

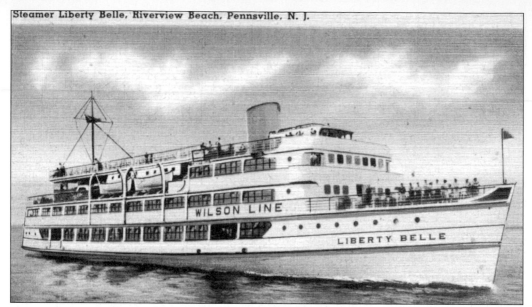

WILSON LINE

LIBERTY BELLE

The Wilmington Steamboat Company, better known as the Wilson Line, ran steamboats between Wilmington, Delaware; Philadelphia, Pennsylvania; and Trenton, New Jersey. A trip to Riverview Beach Park on a boat like the *Liberty Belle* often included a leisurely two-and-a-half-hour cruise down the river from Philadelphia, featuring live music and dancing. The park featured the usual rides and entertainment of any large amusement park. The Wilson Line ended the excursions to the park in 1961.

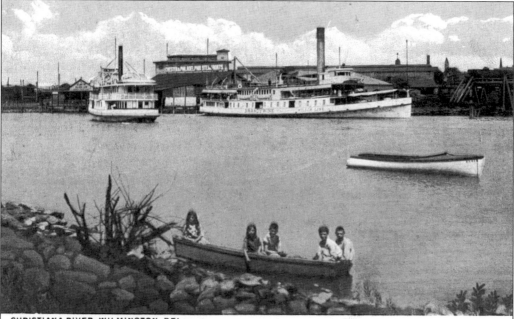

CHRISTIANA RIVER, WILMINGTON, DEL.

The lower Christina River in Wilmington, Delaware, is tidal and accessible from the Delaware. This postcard shows the docks of the Wilson Line and two of its ships. Harlan & Hollingsworth built the *Brandywine* in 1885. The ship was rebuilt in 1936 and renamed the *Pilgrim Belle,* but continued as part of the Wilson Line's fleet.

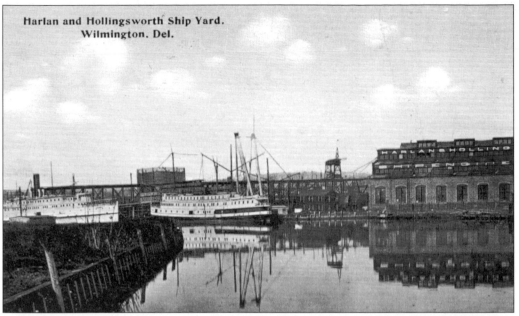

Harlan and Hollingsworth Ship Yard.
Wilmington. Del.

Harlan & Hollingsworth helped make Wilmington, Delaware, a major player in the construction of both ships and railroad cars. Although originally begun by local industrialists, the company was part of the Bethlehem Steel Corporation by the 1920s. During World War I, the shipyard built nearly 70 ships and employed almost 7,500 people. This postcard shows two steamships docked at the shipyard along the Christina River.

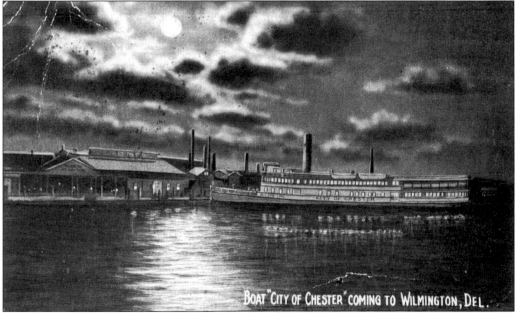

BOAT "CITY OF CHESTER" COMING TO WILMINGTON, DEL.

This night view shows the Wilson Line ship *City of Chester* as it is about to dock in Wilmington, Delaware. Harlan & Hollingsworth built this 612-ton ship in 1888. It was the third ship to join the Wilson Line. The *City of Chester* ran between Philadelphia and Wilmington. It also won several steamship races against ships from other companies. It was rebuilt in 1931 and renamed the *City of Washington*.

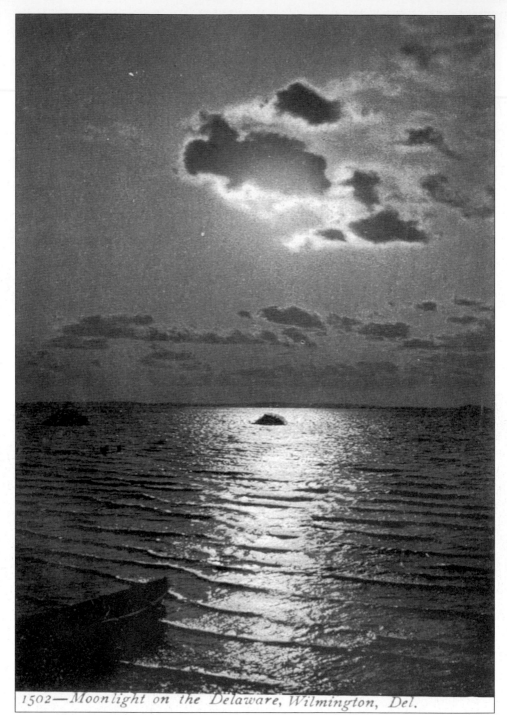

1502—Moonlight on the Delaware, Wilmington, Del.

Although this postcard is a night scene, the photograph was most likely taken during the day and simply colored and printed to resemble moonlight. This postcard view from 1906 looks across the Delaware River in the vicinity of today's Delaware Memorial Bridge. The New Jersey shoreline is seen in the distance. The river here is over a mile wide and about 70 miles from the Atlantic Ocean.

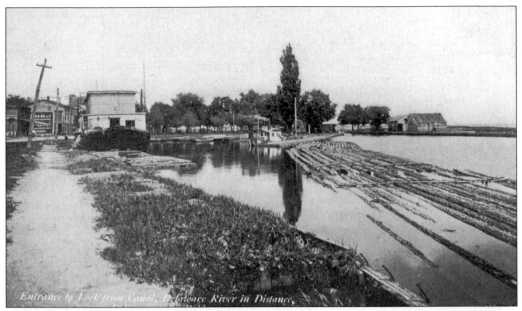

Entrance to Lock from Canal, Delaware River in Distance.

There were great hopes for the development of Delaware City, Delaware, when the Chesapeake and Delaware Canal first opened. Unfortunately, many of these hopes went unfulfilled. Although the canal was vital during the Civil War, tonnage peaked in the early 1880s. Shortly after World War I, however, the federal government acquired the canal and converted it into a ship canal. It still exists in this form.

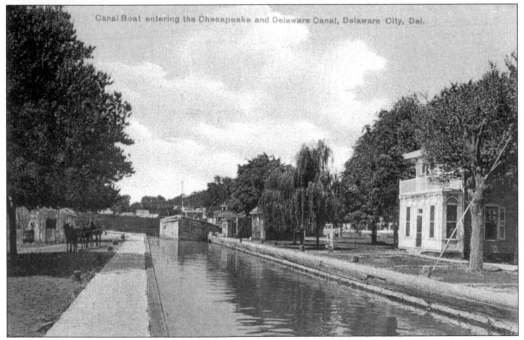

Canal Boat entering the Chesapeake and Delaware Canal, Delaware City, Del.

On July 4, 1829, the 13⅝-mile Chesapeake and Delaware Canal linked the Delaware River and Chesapeake Bay. The Delaware City lock admitted boats directly from the Delaware River. This 1910 postcard shows a barge being towed by a traditional horse and mule team. As early as the 1870s, however, steamboats were the primary vessels used on the canal.

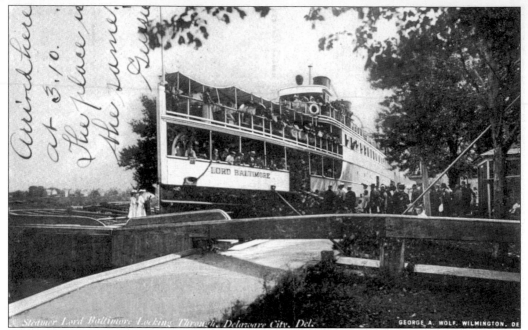

This steamer is most likely part of the Baltimore and Philadelphia Steamboat Company's Ericsson Line. Beginning in 1844, this line of steamships used the Chesapeake and Delaware Canal to carry passengers and freight between Philadelphia, Pennsylvania, and Baltimore, Maryland. This postcard shows the *Lord Baltimore* traveling through the lock at Delaware City, Delaware, *c.* 1905.

DANCING PAVILLION. AUGUSTINE BEACH, DEL.

Augustine Beach, Delaware, was named for Augustine Hermann, a mid–1600s Bohemian adventurer and trailblazer. In the late 19th century, the town was the destination for day trips on the various steamboats. This dancing pavilion was one of many long-gone amusements to be found in the town. Today, two large nuclear-power stations in New Jersey dominate the scenery.

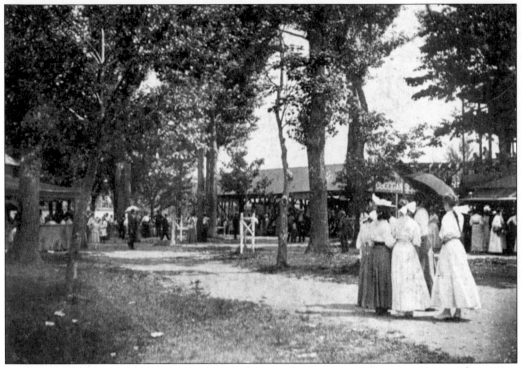

Woodland Beach was a thriving Delaware Bay resort town *c.* 1900. James R. "Old Man" Mott created the resort and owned its concessions, rides, and dance hall. In the postcard above, the sign for a toboggan ride is visible above the group of girls. The postcard below shows a boating party about to embark for a trip on the Delaware from the pier at Woodland Beach.

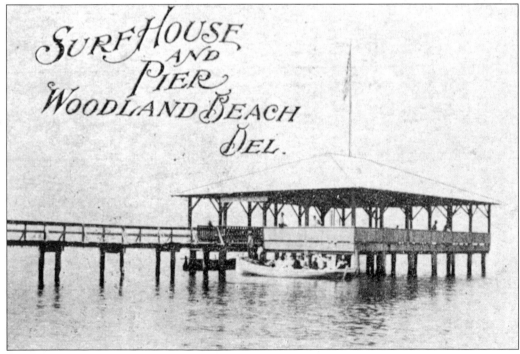

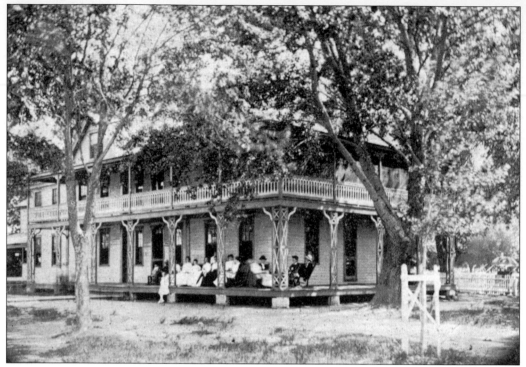

Not much is known about the Woodland Beach Hotel. Delaware is south of the Mason-Dixon line, and the hotel also has a southern feel.

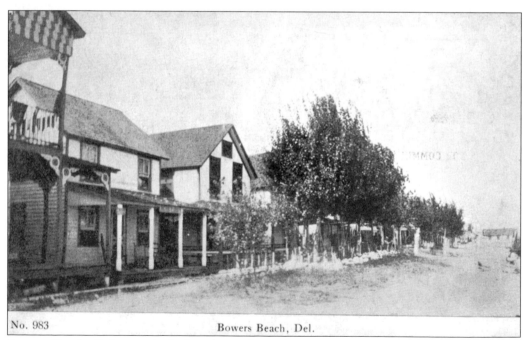

No. 983 Bowers Beach, Del.

Bowers Beach, Delaware, is further down the Delaware Bay shore. This postcard, mailed in 1909, shows a row of houses that may belong to some of the oystermen and other fishermen. Fishing and oystering were the lifeblood of early Bowers Beach.

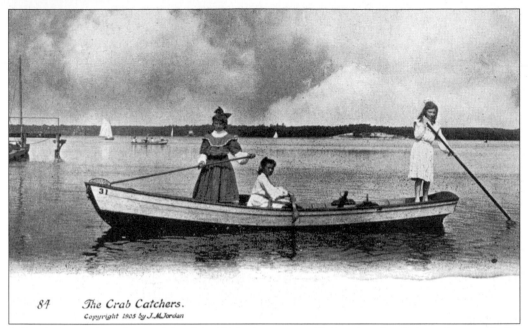

84　*The Crab Catchers.*
Copyright 1905 by J.M.Jordan

"The Crab Catchers," copyrighted in 1905, shows an unlikely trio of well-dressed young ladies crabbing in the Delaware River—possibly for blue crabs. The location is unknown. Crabbing took place as far upstream as Pennsylvania. Commercial fishing and sportfishing remain important industries in the bay.

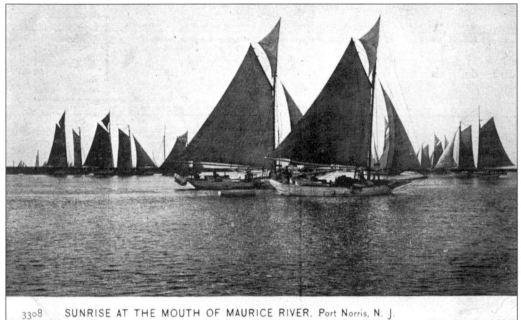

3308　SUNRISE AT THE MOUTH OF MAURICE RIVER, Port Norris, N. J.

Oyster schooners from Port Norris, New Jersey, are shown here. At the peak of the oyster industry, Port Norris had more millionaires per square mile than any other town in New Jersey. Today, a restored oyster schooner, the *A.J. Meerwald,* serves as a traveling classroom while the Rutgers University Haskins Shellfish Research Laboratory in Bivalve, New Jersey, searches for a remedy for the disease that decimated the Delaware Bay oyster populations.

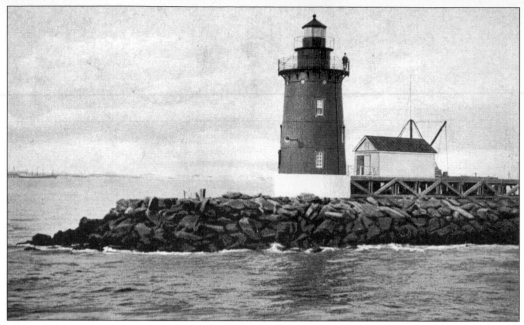

Beginning in 1885, the Delaware Breakwater East End Lighthouse guided ships from its spot on a rocky wharf in the Delaware Bay. The shifting sands of the coastline made the lighthouse obsolete by the end of the 20th century, and it now stands empty. The lighthouse can still be seen from the shores of Cape Henlopen State Park in Lewes, Delaware.

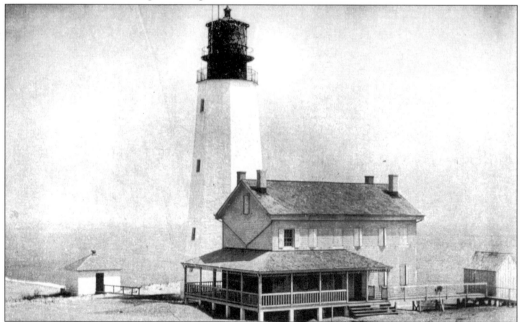

From 1765 to 1926, the Cape Henlopen Lighthouse presided over the coast of Lewes, Delaware. Its strategic location marked the end of the Delaware Bay and the beginning of the Atlantic Ocean. Unfortunately, the sand hill that it was built upon was ever shifting and changing. At around 1:00 p.m. on a beautiful spring day in April 1926, the tower toppled over the edge of the hill and was destroyed.